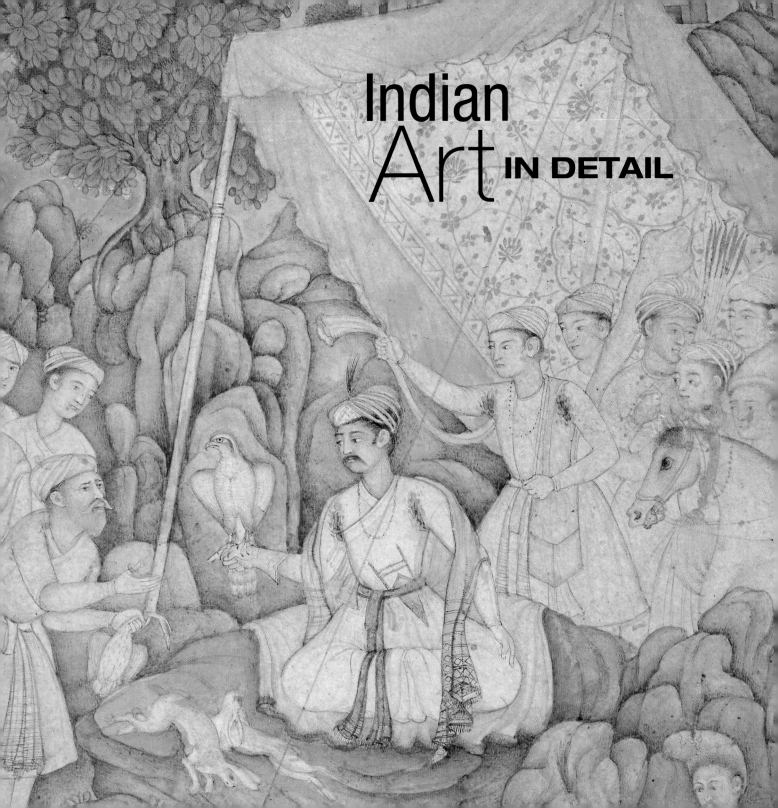

Indian
Art IN DETAIL

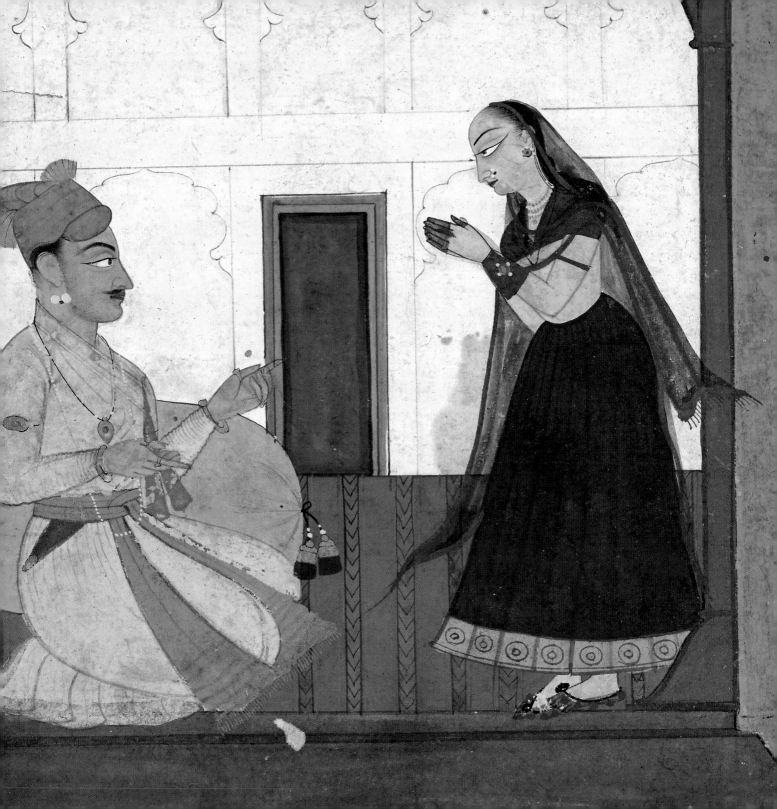

Indian
Art IN DETAIL

A. L. Dallapiccola

HARVARD UNIVERSITY PRESS
Cambridge, Massachusetts

HALF-TITLE PAGE: Detail of a prince, seated under an embroidered awning and holding a falcon perched on his wrist, receiving the bag after the hunt. Mughal, *c*. 1605. Opaque watercolour on paper (see pages 124–5).

TITLE PAGES: The lovelorn heroine. Separated lovers pass through ten different states of mind, ranging from mere longing to death. Here the hero and heroine are shown in two separate buildings: she is on the verge of dying of a broken heart as her confidante visits the hero in his own home. Detail of a page from a dispersed *Rasamanjari*, Basohli, Panjab Hills, *c*. 1720. Opaque watercolour on paper (1962 02 11 02).

RIGHT: Detail of musicians performing for Raja Balawant Singh, Guler, Panjab Hills, *c*. 1745–50. Opaque watercolour on paper (see pages 114–15).

Photography by the British Museum Department of Photography and Imaging (John Williams and Kevin Lovelock)

First published in 2007 by The British Museum Press
A division of The British Museum Company Ltd

A. L. Dallapiccola has asserted the right to be identified as the author of this work

Library of Congress Cataloging-in-Publication Data

Dallapiccola, Anna L. (Anna Libera), 1944-
 Indian art in detail / Anna L. Dallapiccola.
 p. cm. — (Art in detail)
 Includes bibliographical references and index.
 ISBN-13: 978-0-674-02691-9 (alk. paper)
 ISBN-10: 0-674-02691-8 (alk. paper)
 1. Art, Indic. I. Title.
 N7301.D26 2007
 709.54—dc22 2007008798

Designed and typeset in Minion and Helvetica by Peter Ward
Printed in China by C&C Offset Printing Co., Ltd

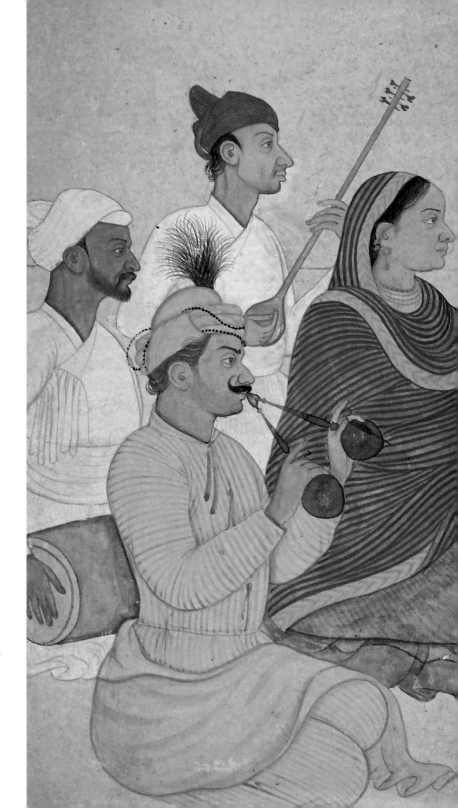

Contents

Preface 6

1 Introduction: What is Indian art? 8

2 Gods 10

3 Heroes 58

4 Devotion 78

5 Courtly and village life 104

6 Further information 138
 Further reading 138
 Principal collections of Indian art 139
 Timeline 140
 Glossary 142
 British Museum registration numbers 143
 Index 144

Preface

The first information on Indian deities to be found in Western sources comes from Greek authors. In describing the victorious campaign of Alexander the Great to India, in 327–326 BC, they dwell at length on the customs and manners of the Indian people. They speak of a god, Krishna, whom they identify with the Greek god Dionysos, who was known to have conquered India, and Alexander himself was eager to surpass Dionysos' achievements and march further into uncharted territory, which, incidentally, he did. The other god they noticed was Shiva, whom they identified with Heracles. Despite this early interest in Things Indian, the reception of Indian and especially Hindu art in the West has been problematic. From the end of the Middle Ages it has been a greater source of debate among the learned than any other non-European art tradition. This is not the place to examine the nature of these debates, but rather to look at the objects afresh, from a 21st-century perspective. This book is divided into four main sections: gods, heroes, devotion and courtly and village life. The objects, all from the rich collections of the British Museum, are arranged by themes rather than chronologically.

The connection between the Indian subcontinent and Britain goes back at least to 1601, when the East India Company was established for the purposes of trade. The links continue up to the present day through shared populations and history, two-way commerce, a common language, educational exchange and many aspects of intertwined cultural life. Given this history, it is not surprising that the British Museum contains one of the most comprehensive collections illustrating the culture of South Asia; it is surely one of the most varied. These collections range chronologically from Palaeolithic stone axe-heads through to the works of 21st-century artists, and from miniature paintings produced in 17th-century courtly ateliers to sculptures of rural deities made of papier maché and used by storytellers.

These collections are to be found primarily in the Department of Asia (which now incorporates the Museum's large ethnographic collections from South Asia), but also in the departments of Coins and Medals and of the Middle East. Examples of this great variety can be viewed on the Museum's website. Further, from late 2007, all the database records of the two-dimensional works of Indian art – primarily paintings, drawings and prints, but also some of the textile collections – will be available electronically. Meanwhile, this book provides an ideal opportunity to see at close quarters, and

to understand, some of the great works in this collection – as well as many that are less well known.

The Indian collections have been gathered together in Bloomsbury over more than 250 years. It is noteworthy that when Sir Hans Sloane, whose collections formed the foundation of the British Museum, died in 1753, there were already contemporary paintings from the Deccan courts of southern India in his collections (these can still be viewed in the displays in the Enlightenment Gallery, Room 1). These are the earliest-acquired Indian items in the Museum. Indian sculpture arrived later, especially in two outstanding acquisitions associated with that polymathic collector Sir Augustus Wollaston Franks – the Bridge Collection (in 1872) and the collections of the disbanded India Museum, the museum of the East India Company (in 1880). The former is of special interest as it had been put together in India by the remarkable Major-General Charles Stuart, known to his East India Company contemporaries as 'Hindoo' Stuart on account of his advocacy of the virtues of Indian culture. The latter acquisition included the remarkable series of sculptures from Amaravati, the early Buddhist site in Andhra Pradesh. Collections of paintings from the Indian subcontinent have entered the Museum throughout its history, with the result that examples range from the 12th century to the present and from the Himalayas to Sri Lanka. Finally, from 1938 onwards, the South Asian collections at the Museum have benefited very substantially from the generosity of Percy Brooke Sewell, especially through the terms of his will, as this provided funds for the acquisition of important works of art from the subcontinent.

The permanent displays of South Asian sculpture can be found in the Hotung Gallery, Room 33, while temporary exhibitions feature periodically in Room 91. The latter sometimes include examples of Indian paintings from a wide range of regional, chronological and functional traditions.

Considerable help and encouragement in the production of this book have been given by Richard Blurton and Sona Datta in the British Museum Department of Asia, the photographers John Williams and Kevin Lovelock, Nina Shandloff and Axelle Russo at the British Museum Press, and the book designer Peter Ward and editor Judith Hannam, to all of whom the author expresses her heartfelt gratitude.

1

What is Indian art?

Home to over a billion people, India is comparable to Europe from the Atlantic to the Urals. Each region is a land in its own right with its particular language, dress code, religious and cultural traditions. Yet shared social systems, grounded on religious beliefs, provide the cohesive force uniting its population. Indian art has developed within Buddhist, Jain and Hindu religious traditions. These share many symbols and motifs which have inspired artists over the centuries, also influencing the arts of Islamic and Christian India. Temples and a sizeable number of stone and metal sculptures depicting deities, religious personalities and emblems have defied the ravages of the Indian climate over the centuries. But the majority of art objects intended for everyday use were made from perishable materials such as clay, wood, ivory and textiles, and so have rarely survived. Remaining fragments bear testimony to the accomplished technique and sensitivity of the Indian artists. Illuminated manuscripts were often kept in palaces or religious institutions, where they have fared marginally better.

Each cultural region of the subcontinent had its individual artistic tradition, dictated by the availability of material and the specific cultural and aesthetic sensibility. Diverse materials required different carving techniques, which were instrumental in the formation of the different regional styles. Specific themes are also connected with particular regions, and those popular in a given historic period could be subsequently forgotten and perhaps revived centuries later. This depended on the religious affiliations and cultural tastes of the rulers, who, with their families, members of their courts, merchants and courtesans, were the major patrons of the arts.

From earliest times craftsmen were organized in guilds, and artists worked in well-supplied court ateliers. However, patronage was not always forthcoming, so artists led a nomadic life wandering from court to court and had to adjust their style to the new patrons. There may have been women artists, but unfortunately nothing is known about them. There were certainly keen women patrons and art connoisseurs. Women were and still are associated with the creation of specific art forms, mainly ephemeral.

One of the most striking features of Indian art is its empathy with natural life. From its beginnings some 5000 years ago, the celebration of life, in all its abundance and

multiplicity of forms, has been its *leitmotif*. Plant, animal and human merge effortlessly into one other, as in the numerous hybrid creatures which appear in the mythology, folklore and arts of India. Trees play an important role and are worshipped as a symbol of reproduction or the continuity of life. Animals, both fabulous and real, feature prominently in depictions of religious stories, folk tales and classic literature. Several creatures are associated with specific roles for particular deities.

The ever-present female images in art are the embodiment of the female principle, essential for the propagation of life. Mother goddesses have been worshipped for at least 4000 years in both benign and awe-inspiring forms. Human couples, tenderly embracing, reflect the union of the male and female principles, or of heaven and earth. They are considered auspicious symbols of creation and the continuity of life.

Just as strong as the celebration of nature is an awareness of the transience of life and hence the spiritual dimension. Indian philosophy regards all manifestations of phenomenal reality as transitory and conjured up by *maya*, imagination, the flux in which everything is created, dissolved and recreated. In order to escape from this endless entanglement, the wise should seek *moksha*,

liberation from the cycle of birth, death and rebirth. This can be done by leading a balanced life, in accordance with one's status and social and moral duties, or by embarking upon a life of renunciation, or through personal, unconditional and selfless devotion to a deity. Another way of escaping the enticement of *maya* is to retire to the wilderness to meditate under austere conditions – ascetics are ubiquitous in Indian art, reflecting the example of the Buddha and his near-contemporary Mahavira, founder of Jainism.

Expressed through its multiplicity of forms and vibrant colours, Indian art is essentially a celebration of life in all its aspects. In Hindu mythology, plants, minerals, animals, humans and divine beings are all part of a revolving cycle in which death is not final destruction, but merely a prelude to a new creation, filled with endless potentialities.

This selection of objects, all drawn from the collections of the British Museum, illustrates some 2000 years of Indian art. Ranging from monumental stone sculptures to minute and painstakingly finished ivory carvings, from paintings on paper and cloth to ritual objects, all testify to the mastery of Indian artists and craftsmen, both at court and in the village.

2
Gods

Hinduism, the religious tradition followed by the majority of the inhabitants of the Indian subcontinent, is an extremely complex religious system whose core values are shared by its followers, irrespective of differences in language, culture, dress and diet.

Although traditionally there are some 330 million deities, the major cults of Hinduism focus on the main three: Vishnu, Shiva and the Devi or Shakti, the great goddess in her multifarious aspects. Their personalities display diverse and often contrasting elements which have coalesced over the centuries, as demonstrated by the different aspects under which they are worshipped today. Furthermore, there are also local gods and goddesses, semi-divine beings, deified heroes, ascetics and, predictably, numerous and diverse schools of thought. In the light of this, it would perhaps be advisable to speak of Hinduisms, held together by common elements such as the authority of the Vedic tradition, the caste system, religious and moral law, epics and myths, and deep respect for spiritual teachers.

Hindu belief is solidly grounded on the authority of the four Vedas, the oldest of which dates from *c.* 1500–1200 BC. These are sacred texts in Sanskrit, believed to be composed by the Aryans. These collections of hymns sing the praises of various deities, among which are many of those still worshipped in contemporary India. The Vedic religion, also known as Brahmanism, gravitates around complex sacrificial rituals which could be performed only by Brahmins. These rituals ensure that the gods, periodically reinvigorated through sacrifice, will, in turn, ensure the prosperity and well-being of mankind. Apart from acknowledging the authority of the Vedic tradition, Hinduism has no unique doctrinary basis. This has allowed the coexistence of the most disparate religious traditions during the last 2000 years or so. A characteristic feature of Hinduism is that the worship of these deities is not mutually exclusive: a follower of Shiva will also worship Vishnu, albeit as a secondary deity, and vice-versa. The followers of Devi, however, will regard all male deities as less important. Some schools of thought maintain that all these diverse deities are but facets of the transcendent divine, an attitude that encourages tolerance. This coexistence, however, was not always peaceful: critique, dissent and heterodoxy gave voice to new currents of thought.

The concept of a trinity consisting of Brahma, Vishnu and Shiva was introduced. Brahma, the 'Creator', is the pivot between two opposing forces: the centripetal Vishnu, the 'Preserver', and the centrifugal Shiva, the

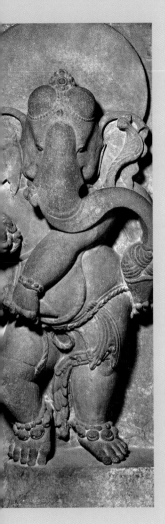

Dancing Ganesha, southeastern Uttar Pradesh. Sandstone, mid 8th century.
Ganesha is the Lord of Obstacles and the Lord of Beginnings, the most popular and important god throughout India. Worshipped before all religious ceremonies and new undertakings, his protection is invoked at the beginning of books.

'Destroyer'. These have one or more consorts, offspring, and are surrounded by a multitude of minor deities, some of which are of local importance, such as Minakshi, the tutelary goddess of Madurai, or Shri Nathji of Nathdwara. Many local deities have been co-opted into the families of the main deities, as for instance Minakshi, who was probably a local goddess and became the consort of Sundareshvara, an aspect of Shiva, at Madurai. Despite her being part of Shiva's family, she remains the queen of Madurai and her consort has a less prominent position.

A striking feature of Hinduism is that deities, after attaining tremendous popularity in a particular region, can be forgotten for some time and then suddenly make a comeback. New deities are also introduced, for instance Santoshi Mata (the 'mother of contentment'), who emerged during the 1950s and quickly gained an astonishing following in northern India.

Hindu mythology revolves around light and darkness, creation and destruction, good and evil. Buddhists, Jain and Hindus see creation as a cyclical process. Each time a universe comes into being, it gradually deteriorates until it is destroyed in a huge conflagration. This, however, is not the end; after a period of quiescence, the creative process starts afresh. Even the most benevolent deities have a dark side, which occasionally emerges: the great goddess Devi appears in benign and awesome aspects as Parvati or as Kali. The same applies to all other gods in their diverse aspects as protectors of their devotees and destroyers of the negative forces which threaten creation. The cyclical conception of time constantly shifts the balance between good and evil; the gods and their adversaries are forever locked in a conflict. This dynamic relationship between the gods and the anti-gods is the theme of many myths, in which both parties try to outwit each other. There is no final victory: sometimes it is the gods who are ignominiously defeated, and other times it is their adversaries. Myths provide an endless source of artistic inspiration, as amply demonstrated by the wealth of images and narrative friezes sculpted or painted on temple walls and in books, theatre, dance and, more recently, cinema and television productions.

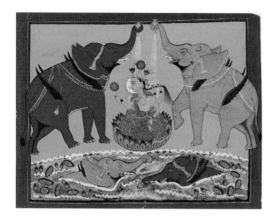

Gaja Lakshmi, Bundi. Opaque watercolour on paper, *c*. 1780.

Emerging from a lotus-filled pool and seated on a lotus, Gaja Lakshmi, the goddess associated with fertility, riches and royalty, carries a lotus flower in her upper right hand, an elephant goad in her lower left, and with her two free hands she wrings the water from her hair. Two elephants, carrying golden pitchers in their trunks, collect water from the lotus-filled pool and pour it over her. Gaja Lakshmi bathed by the elephants is one of the most ancient and enduring motifs in Hindu and Buddhist iconography.

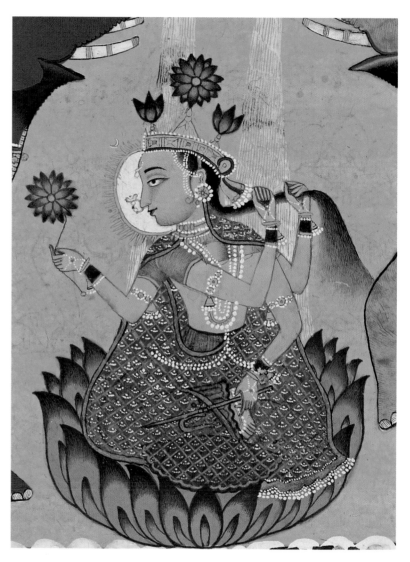

The goddess is depicted wringing water from her hair, an intimacy highly unusual in a sacred image, whose rendering is strictly codified by centuries of tradition. She is dressed in a skirt and short blouse, and her body is draped in a diaphanous veil. The palms of her hands and soles of her feet are slightly reddened. Three lotus flowers adorn her crown, and her carefully drawn profile is enhanced by the surrounding white halo, against which her elaborate nose-ring stands out dramatically. Her earrings, necklaces, armlets, bracelets, chains, waist ornament and anklets are lovingly drawn.

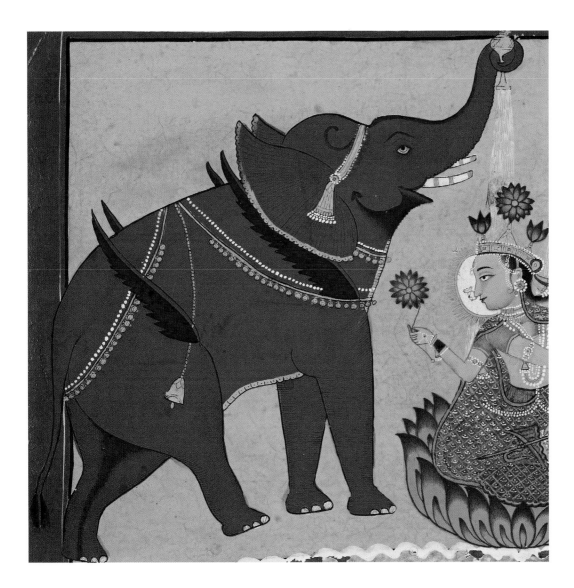

These elegantly decorated elephants have four diminutive wings. These refer to the belief that once elephants not only had wings but also, like the clouds, could change their form at will. Eventually they lost these attributes, but a strong connection remains with clouds and rain and therefore fertility and prosperity.

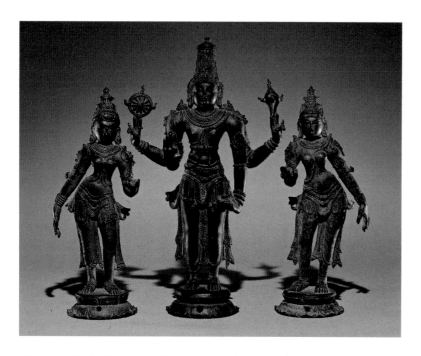

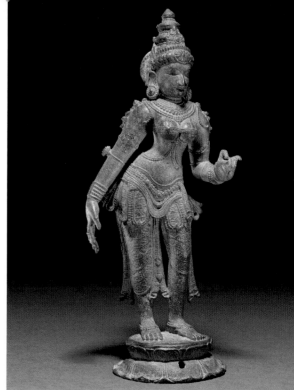

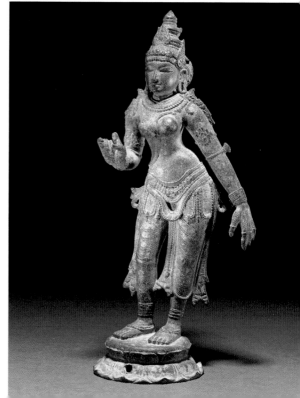

Vishnu with Shri Devi and Bhu Devi, central Tamil Nadu.
Bronze, c. 1000.

These exquisite pieces were produced during the Chola period (9th–13th century), when the art of bronze casting attained an unparalleled degree of excellence. Vishnu is portrayed as a youthful royal figure, elegantly dressed and bejewelled. His consorts, Shri Devi, also known as Lakshmi or Shri Lakshmi, a personification of prosperity, wealth and fame, and Bhu Devi, the earth goddess, whom he rescues in his incarnation as Varaha, the Boar, stand gracefully at his sides. His association with the two goddesses reflects his royal status: a king is symbolically wedded to the earth, and his first and foremost duty is to protect her. Shri Devi is also connected with royalty: the fertility of crops, animals and the prosperity of the population depend on the king scrupulously performing his moral duties and ritual obligations.

LEFT: The two goddesses are dressed alike and wear the same jewellery but for one item. Shri Devi (above), the senior wife, stands on her consort's right and wears a breast band, whereas Bhu Devi (below), the junior wife, stands on his left and is usually bare-breasted. Both have one arm flexed with the fingers poised to carry a flower.

RIGHT: A magnificent crown covers Vishnu's head. He wears earrings, shoulder ornaments, necklaces, armlets, bracelets and anklets. Across his chest are a conspicuous sacred thread and a stomach band. An elaborate girdle with an intricate clasp adorns his waist, and a waistcloth is gracefully draped on his hips. His two upper hands carry his typical attributes of *chakra* (discus) and *shankha* (conch), the lower right is in *abhaya mudra*, the reassurance gesture, and the left is placed on his thigh.

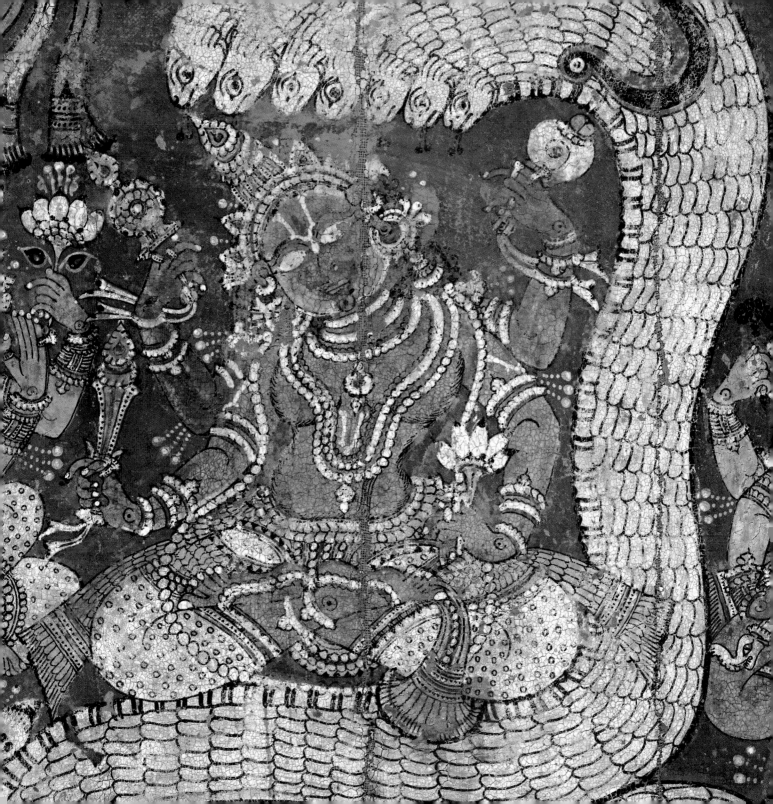

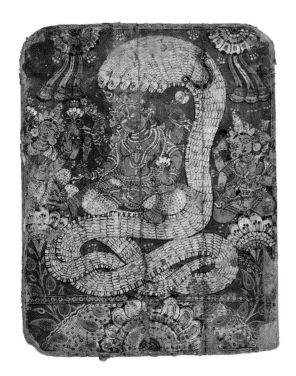

The god Vishnu and his consorts, Orissa or coastal Andhra. Pigments on cloth pasted on board, late 18th century.

The four-armed god Vishnu sits on the coils of the seven-hooded snake Shesha. Set off by the dramatic red background, his supple blue body, with his crowned head tilted towards the left, echoes the sinuous body of the snake. To his right is the four-armed goddess Shri, holding lotuses in her upper pair of hands while with her lower pair she pays homage to her consort. To his left is the goddess Sarasvati. Both goddesses have a golden complexion and sit on lotuses, which sprout from a larger one supporting Vishnu on Shesha, as if to suggest that all three deities originate from it. Rosettes and streamers enliven the top corners of the painting.

Sarasvati, goddess of learning, music and the arts, is one of Vishnu's consorts, according to the eastern Indian tradition. She is here shown with her typical attributes: the book in her upper left hand, the lotus flower in her upper right and the *vina*, a string instrument, in her lower pair of hands.

Vishnu sits cross-legged on the snake Shesha, the cosmic serpent, whose coils symbolize the endless revolutions of time. Dressed in a dhoti tied at the waist by a sash, Vishnu carries in his four hands his typical attributes: the discus and conch in his upper hands, and the mace and lotus flower in his lower ones. Painted on his forehead is the typical Y-shaped Vaishnava mark, the *namam*, here shown with a red vertical line at its centre.

Canopy, Kalamkari, probably from Kalahasti.
Pigments on cloth, late 19th century.

This is probably a canopy, which was hung above a sacred image. It is divided into 13 fields: the central one is occupied by a lotus, with the 12 remaining ones arranged around it. The iconographic programme consists of the ten *avataras* of Vishnu, plus Ganesha and a *linga*. The borders of the canopy display a chevron pattern and the background is enlivened by a small floral motif. The two central figures on each side of the cloth are shown standing beneath a lobed arch, whose squinches display small abstract designs.

Vishnu's second incarnation as tortoise: the god is shown as half-man, half-tortoise. In his upper hands he carries the conch and the discus, while his lower hands are empty. He wears a crown from which fillets cascade on to his shoulders, plus all the usual ornaments. A shawl is draped over his elbows. Near him is a diminutive tortoise supporting a mountain around which is coiled a snake.

Kalki 'having a white horse' is the last incarnation of Vishnu, which will mark the end of the universe. The deity is depicted as a human torso emerging from a horse's sumptuously caparisoned body. In his upper hands the god carries the usual conch and discus, in his lower right he brandishes a sword, and in his lower left he holds a buckler.

Ganesha, shown frontally, sits on his conveyance, the bandicoot, and rests his back on a large bolster from which emerges a frame-like halo. The deity carries in his upper right hand a noose, in his upper left the elephant goad, his lower right carries, possibly, his broken tusk, and in his lower left is a bowl of sweets. Unusually, the bandicoot looks ferocious, with bared teeth, bristling whiskers and extended claws.

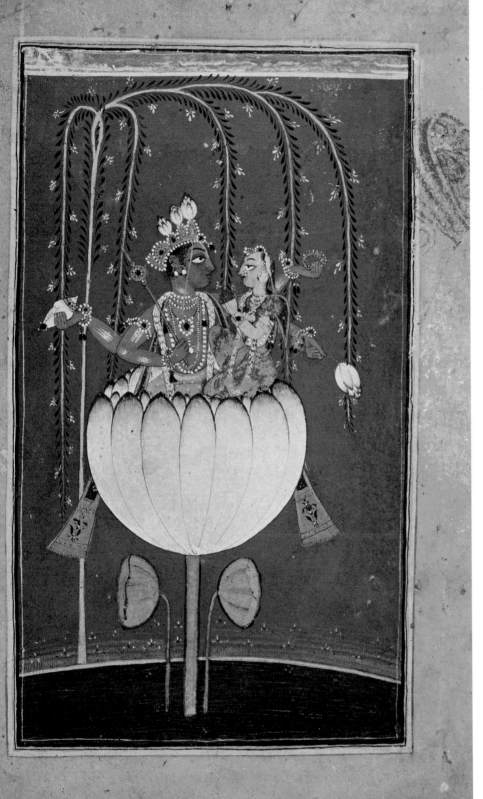

**Vishnu and Lakshmi in a lotus,
Basohli, Panjab Hills.
Opaque watercolour on paper, *c.* 1730.**
Vishnu and Lakshmi are seated together
embracing inside a lotus, which emerges
from a lake. The divine pair gaze at each
other in rapt admiration, oblivious to
everything else. In love poetry, the eyes
of the lover are compared to the *chakora*
birds, which were supposed to feed on
the rays of the moon: the moon, in this
case, is the beloved's luminous face.
The god carries in his arms his usual
attributes: the conch, mace, discus and
lotus flower. The lotus supporting the
divine pair may symbolize the universe
emerging from the waters of
non-existence, through the creative
power of Vishnu. A superb weeping
willow completes the picture.

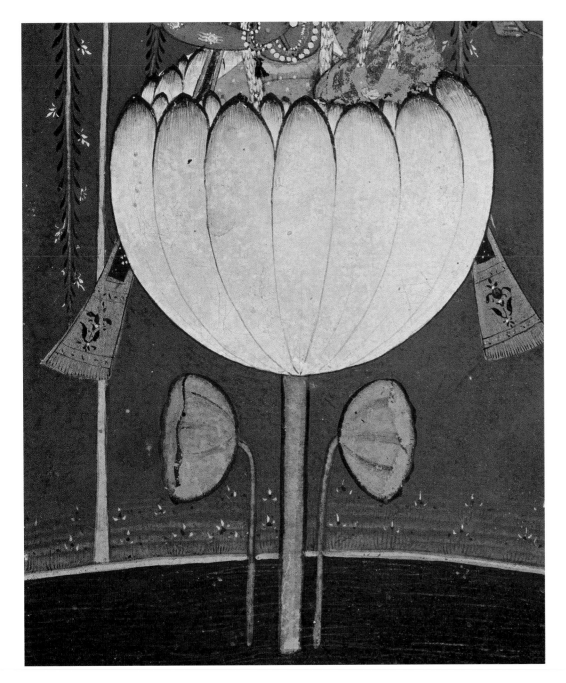

The lotus, rich with associations and symbols, plays an important part in Buddhist, Jaina and Hindu art. It represents creation, cosmic renewal and purity. Because drops of water slide off its leaves, it symbolizes detachment. It is said to have originated from Vishnu's navel as a thousand-petalled lotus on which Brahma sat. The majority of sacred images stand or sit on a lotus pedestal, indicating their unsullied nature.

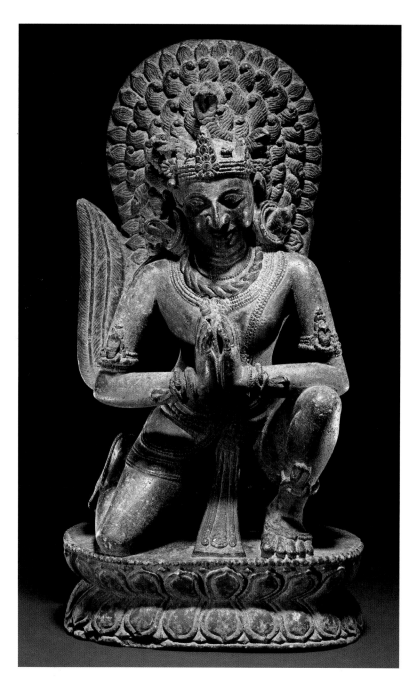

Vishnu's vehicle, Garuda, Orissa. Schist, 13th century.

Garuda is the vehicle of Vishnu, sometimes described as an eagle, sometimes as a kite. Usually, however, he is rendered in part-human form, with the wings of a bird and with a prominently curved beak instead of a nose. Garuda is shown here as a handsome youth, a benevolent smile playing on his lips while he kneels with his hands respectfully folded in *anjali mudra*. Dressed in a short lower garment, he wears snakes as ornaments. Only one of his wings has survived. This image was probably placed opposite one of Vishnu. Garuda symbolizes the solar energy. His rivalry with the snakes, symbolizing the chthonic or earthly element, is a recurring theme of Hindu mythology.

One of the arresting features of this Garuda image is the curly hair radiating from his head as sunrays, while each ringlet is shaped like a cobra's head. His victory over the snakes, symbols of the earth, moisture and darkness, is hinted at in his ornaments: a cobra emerges from the crown of his head and coiled cobras are his earrings, armlets, bracelets and anklets.

Hanuman, probably Karnataka.
Brass, late 18th century.

Hanuman, whose name means 'heavy-jawed', is the monkey-hero whose fame and career are inextricably linked to Rama's. He is one of the most popular gods of Indian mythology and folklore, famous for his prowess, his selfless devotion to Rama, and for his marvellous adventures. Gifted with superhuman powers – which are attributed to his celibacy – he can change his shape at will. His ebullient, positive and resourceful character is the perfect foil to Rama's severe, duty-conscious and, at times, remote self. Hanuman is the greatest of Rama's devotees, and he is believed to sing hymns in praise of his lord when not otherwise occupied. In this brass plaque, Hanuman is shown in his heroic mood, straddling a supine warrior, probably one of Rama's enemies, holding an uprooted tree in his left hand, possibly the magic plant which will revive Rama's brother, Lakshmana, wounded in battle, and with his right hand raised menacingly. The typical Vaishnava emblems, the *chakra* and the *shankha*, with flames issuing from their tips, are shown on the rim of the plaque. These plaques were generally worn on the chest by a group of Vaishnava mendicants, the Dasaris (see page 130).

At the top of the rim, on a lotus pedestal supported by Hanuman's tail, a chubby baby Krishna dances, with a butterball in his hand. Behind him a five-hooded *naga* rises protectively. This motif is frequently found in jewellery, especially pendants and hair ornaments. Two parrots complete the tableau.

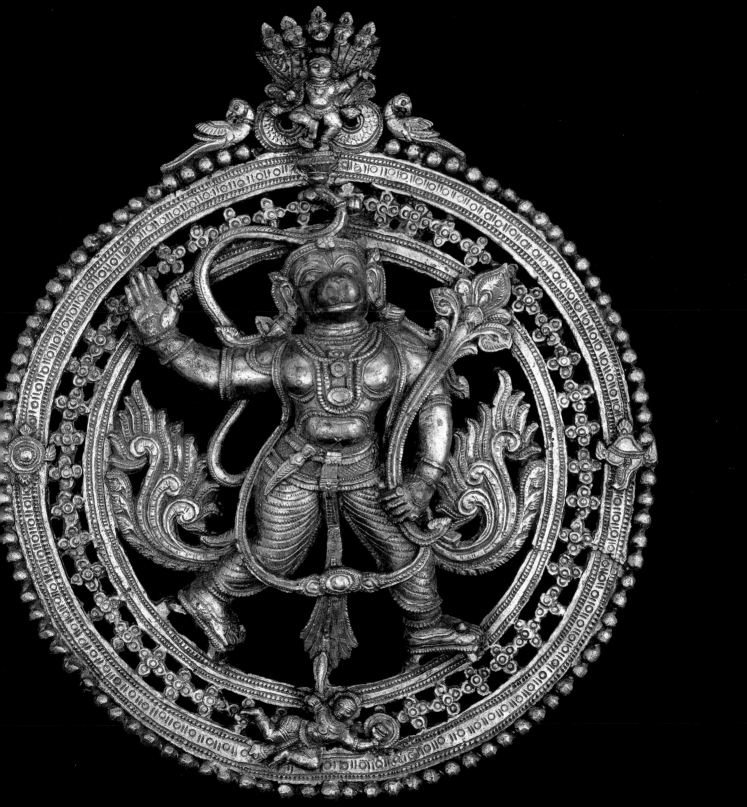

Lamp with Krishna playing the flute, Kerala. Bronze, 12th–13th century.

On one side of this lamp Krishna is shown fluting beneath the trees, flanked by two maidens and three cows on either side. The god stands on a double lotus, with one foot slightly raised, carrying the flute in his two hands. His four companions carry various objects in their right hands: flowers, a mirror and a box(?). The group is surrounded by an arch displaying various decorative motifs, geometric patterns, foliage, flowers and foliated tufts on the outer rim. The arch is flanked by two rearing *yalis*, and supported by two leaping lions fixed to the base of the lamp. Intricate lamps such as this were hung from the rafters on long decorative metal chains.

On the opposite side of the lamp, Gaja Lakshmi, carrying lotuses in her hands, is bathed by elephants.

Under the branches of two trees, Krishna stands on a double lotus playing the flute. Immersed in his melody, he seems oblivious of his surroundings. He wears a lower garment tied at the waist by an elaborate belt and is bedecked with jewellery.

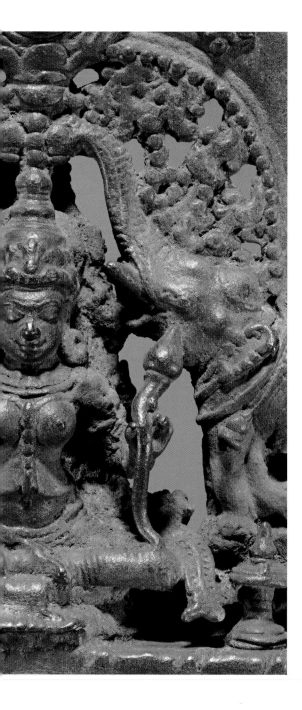

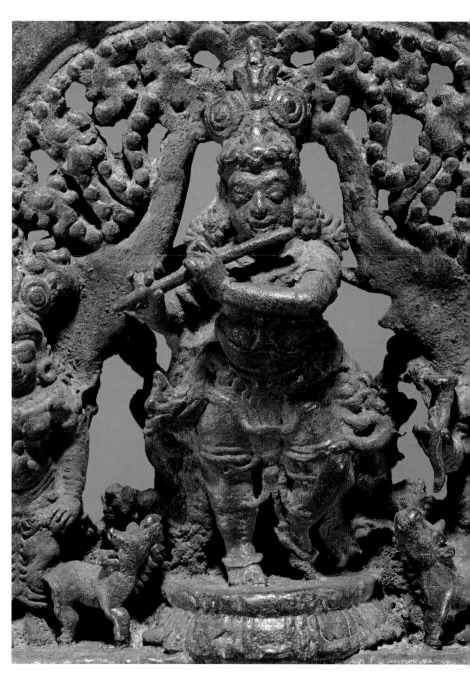

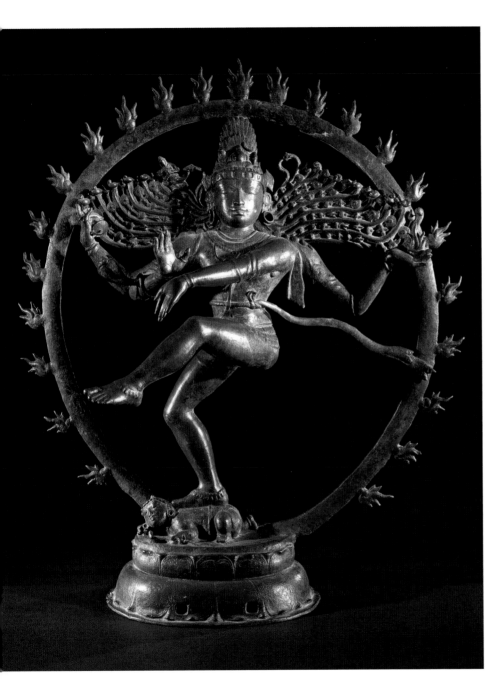

Shiva Nataraja, Tamil Nadu, probably Thanjavur district. Bronze, c. 1100.

In recent centuries, the image of Shiva as Nataraja, Lord of the Dance, has become one of the most famous of Hindu India. This icon, however, was created over a thousand years ago. Shiva is shown dancing the universe into destruction and, at the same time, initiating a new creation. The figure of the dancing god is placed on a pedestal in the shape of a double lotus from which issues a halo of flames. In his upper right hand the god carries an hourglass-shaped drum, in his left a blazing flame. His lower hands are free of emblems: the right points to the sky, and the other to the dwarfish creature, the symbol of ignorance or egotism, which is crushed beneath the god's right foot. The Nataraja image is a visual rendering of the five activities of the god: creation arises from the drum's sound; protection comes from the raised hand; destruction proceeds from the blazing flame; the raised foot gives salvation; and the foot firmly planted on the deformed dwarf gives refuge to the soul enmeshed in the delusion of human life.

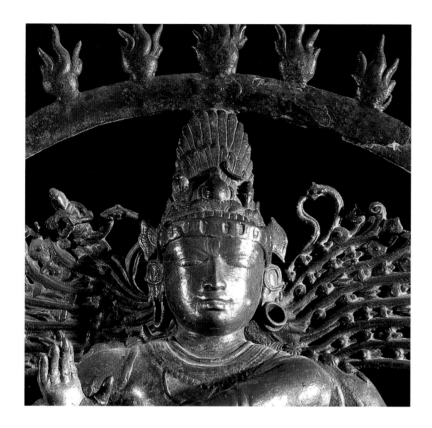

The dance of Shiva ends one creative cycle and initiates a new one, but despite these momentous events, the face of the god betrays no emotion. With the sublime detachment of a yogi, he goes about his business of destroying and creating. In his matted locks are the crescent moon and a cobra rearing its hood, symbolizing time and its renewal. A datura flower and a bunch of cassia leaves are gathered at the top of his head. Amongst the hair flying at the side of his head is a small mermaid figure, the goddess Ganga, the river Ganges. She is said to have come down from heaven with tremendous violence and, in order to save the earth from destruction, Shiva caught her water in his matted hair, thus breaking the force of her fall. The different earrings worn by Shiva indicate his androgynous nature.

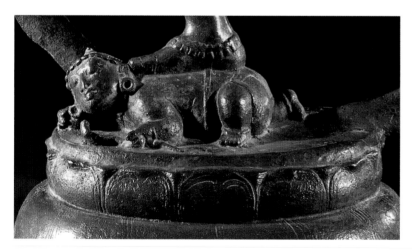

The personification of ignorance, the Apasmara *purusha* is depicted as a small deformed creature, holding a snake in his hand, lying supine under Shiva's right foot. By trampling ignorance and egotism, the devotee will be liberated from the delusions ensnaring his soul.

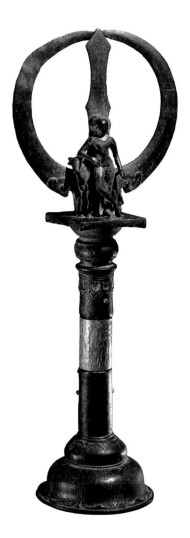

Shiva's trident, Tamil Nadu. Bronze, *c.* 950.

The trident, one of the usual attributes of Shiva and closely connected with him, has become an object of devotion in its own right. Here Shiva leans elegantly against the bull, Nandi, a symbol of the god's virility and strength. The features of the image as well as the details of his clothes and jewellery have been obliterated by centuries of ritual bathing and handling by devotees. The god and his conveyance emerge from the central prong of the trident surrounded by the external prongs, whose elegantly curved shape creates a frame.

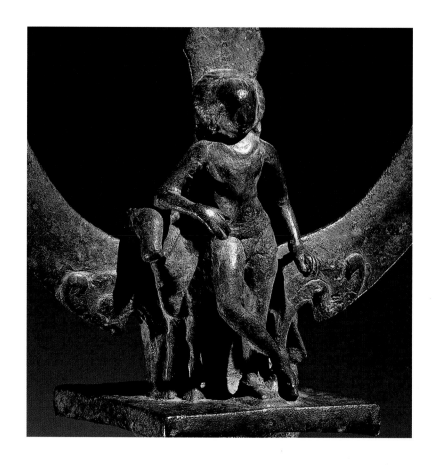

The emergence of Shiva and Nandi from the trident's upright prong beautifully expresses the essential identity between Shiva, his bull Nandi, and his emblem, the trident.

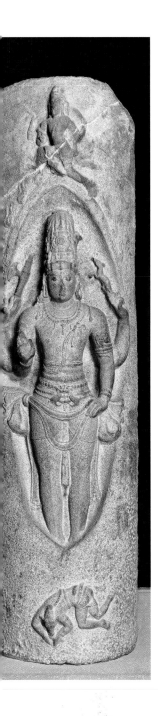

Lingodbhavamurti, Tamil Nadu.
Granite, *c.* 900.

This image combines the symbol of Shiva with an actual depiction of the god bursting out in a mandorla of flames. His figure is shown only from the knees up, to suggest his incommensurability. Above and beneath him are the two gods who were engaged in a dispute about which of them was the greatest when a fiery *linga* suddenly emerged from the ocean: Brahma flew towards the sky and the boar-headed Vishnu plunged deep into the water, but neither was successful in finding the beginning or the end of the blazing *linga*. The crowned four-armed god stands majestically with an axe and a leaping gazelle in his upper hands, his lower right in the gesture of reassurance while his lower left is elegantly placed on his hip.

The sacred thread is delicately carved across Shiva's chest along with the stomach band and other ornaments. A waist cloth is tied in two loops around his hips. The *kirttimukha* or 'face of glory', one of the most popular motifs in jewellery, is shown in the clasp of his girdle. Its redoubtable aspect, with the face of a lion and wide-open mouth, is believed to avert malignant influences and so protect the wearer.

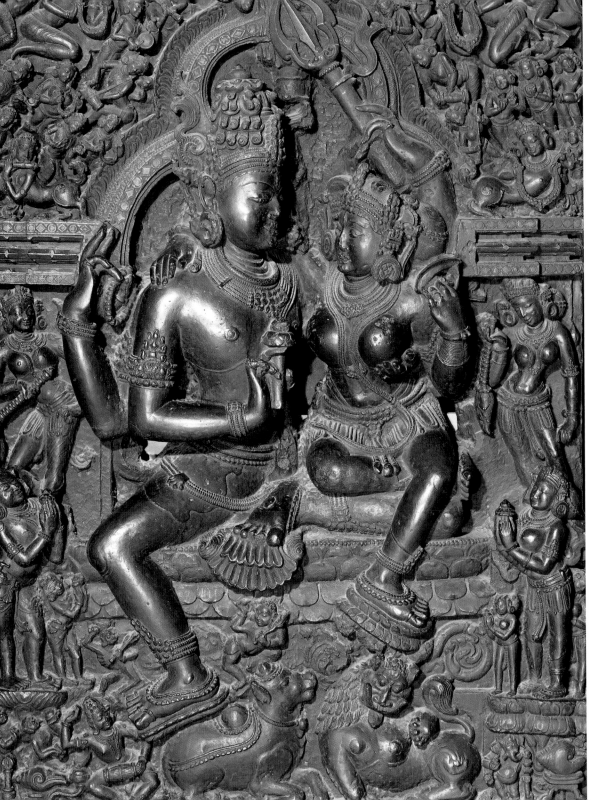
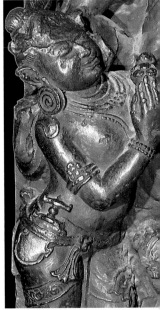
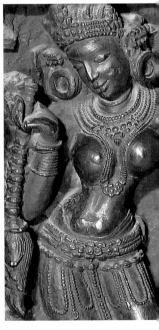

Umamaheshvara, coastal Orissa.
Schist, 12th–13th century.

The goddess Parvati sits on Shiva's flexed left
thigh looking lovingly at her smiling consort. The
divine couple are shown on a double lotus, and
another double lotus supports their feet. Shiva
holds in his upper hands a garland of beads and
his trident and in his lower right a lotus flower.
His lower left arm embraces Parvati's waist and
fondles her breast. The goddess holds a mirror
in her left hand and embraces her husband with
her right arm. The artist dwells lovingly on
details of the deities' hairstyles: Shiva's matted
locks, Parvati's bun decorated with chains and
bejewelled clips, and their headbands, earrings
and necklaces. The third eye, symbolizing
transcendental wisdom, is finely carved on their
foreheads. At their feet are their respective
animal mounts – Shiva's bull and Parvati's lion –
as well as their sons, Skanda and Ganesha.
Unusually, Skanda, in the lower left corner, is
shown playing the drum.

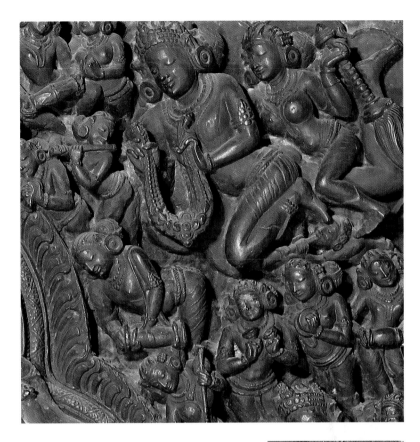

ABOVE: Semi-divine beings such as flying
gandharvas, the musicians and singers of
the gods, and a bevy of other attendants fly
above the heads of the divine couple.

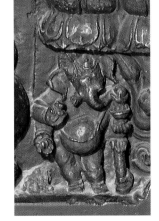

On either side of Shiva and Parvati stand
donors. On the left is a male figure and his son,
both depicted with their hands in *anjali mudra*.
On the right, a female celestial being holds a
fly-whisk.

RIGHT: In the lower right corner, to the right
of Parvati's lion, is the elephant-headed
Ganesha.

Subrahmanya, Valli and Devasena riding on a peacock, Thanjavur.
Opaque watercolour on paper, *c.* 1800.

Subrahmanya sits on a throne placed on his conveyance, the peacock, with his consorts: the fair Devasena to his right, and the dusky Valli to his left. A halo decorated with floral wreaths surrounds the trio. The peacock stands with his talons firmly planted on a cobra, and with yet another snake in his beak. Two *ganas*, the fair-skinned one blowing a conch, the dark one carrying a fly-whisk, precede and follow the group. Their foreheads are smeared in *vibhuti*, sacred ash, and on their bodies are conspicuous *tripundra* marks, the three horizontal lines denoting the followers of Shiva. A line of trees enlivens the background.

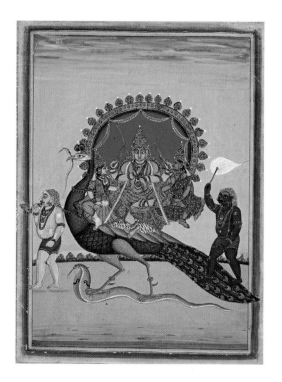

Subrahmanya's left leg rests on the throne and his right hangs down. In his upper pair of hands he carries two daggers with S-shaped blades. His lower hands are held in *abhaya* and *varada mudra* and carry his characteristic weapon, the spear. To the god's right sits his high-caste, fair-complexioned senior wife, Devasena. His favourite, junior wife, the dark-complexioned Valli, born in a hunters' community, sits on his left thigh. It is customary for a number of gods to have two consorts, each from a different community, no doubt designed to encourage communal harmony.

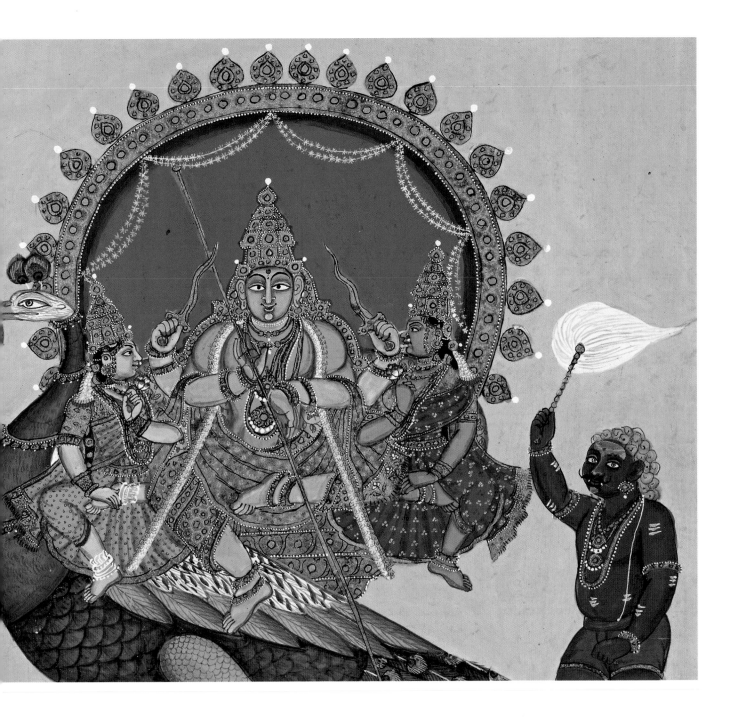

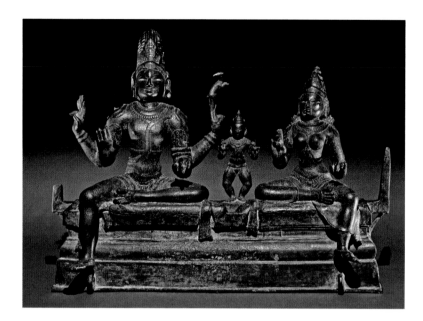

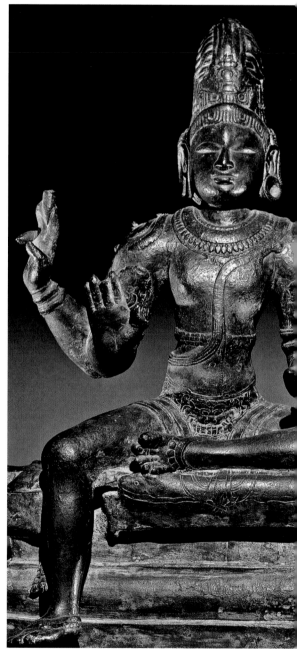

Somaskanda group, Tamil Nadu. Bronze, c. 1100.

This processional image, which became very popular during the Chola
period (9th–13th century) and is known as Somaskanda, depicts Shiva with
his consort Uma, or Parvati, and their son Skanda. The idea of the 'family
group' was a creation of the Pallavas, the predecessors of the Cholas.
Shiva sits to the left, Uma to the right and in the centre is baby Skanda,
with a flower in each hand, dancing merrily. The sculpture would originally
have been framed by an arch decorated with small flames attached to the
two prongs on either side of the group. Before being carried in procession,
the sculpture would have been fastened to a palanquin by means of sturdy
ropes passing through the eyes on its base. The images would then have
been dressed and decorated with jewellery and floral garlands prior to
being taken out of the temple.

BELOW: Uma, or Parvati, sits with her left leg resting on the throne she shares with her consort Shiva and their son, Skanda. She sports a forehead band and a small crown. In her right hand she carries a lotus flower, while her left is in a pose resembling the *varada mudra*, the wish-granting pose.

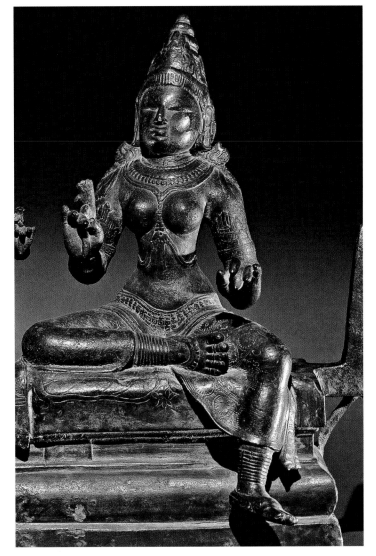

LEFT: Four-armed Shiva sits comfortably in a pose known as 'royal ease', his left leg resting on the throne and his right leg hanging. His dreadlocks are piled up to form a tall crown. In his upper right hand he would have carried an axe, now broken. In his upper left hand is a leaping antelope, a reminder of his status as ascetic and forest dweller. The lower right hand makes a gesture of reassurance and the lower left is held in an elegant pose.

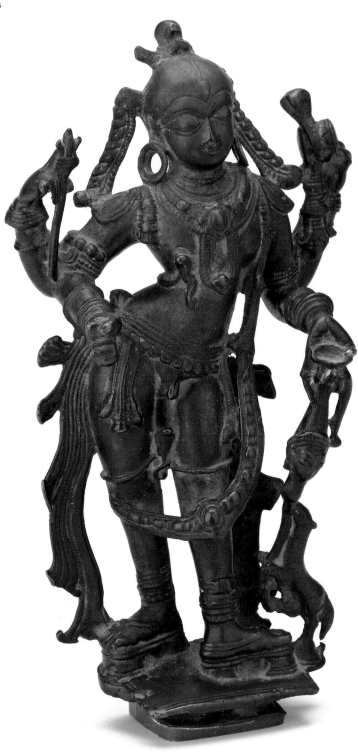

Bhairava, Karnataka. Bronze, *c.* 950.

Bhairava the 'terrible' personifies Shiva's wrathful and destructive side; representations stress his awesome aspect. He is depicted naked except for his ornaments, among which are snakes, and a garland of skulls is draped around him. His matted hair is tied in a topknot and his toe-knob sandals are typical of wandering beggars. Round, bulging eyes and slightly protruding fangs also emphasize his violent nature. In his upper hands are his typical attributes, the trident and hourglass-shaped drum around which a cobra is coiled. In his lower left hand he holds a skull-cup and a severed head. His lower right hand, now empty, would probably have carried a sword. A dog follows him, licking the blood as it oozes from the severed head.

The face of Bhairava is dominated by his eyes. The knitted eyebrows, prominently carved, denote his fierce character, and two long plaits of matted hair frame his face.

A skull-cup rests in the god's palm, while wound around his fingers is the long hair of a severed head. The deity's conveyance is the dog, considered the most impure of all animals, which follows his master greedily licking the drops of blood oozing from the head.

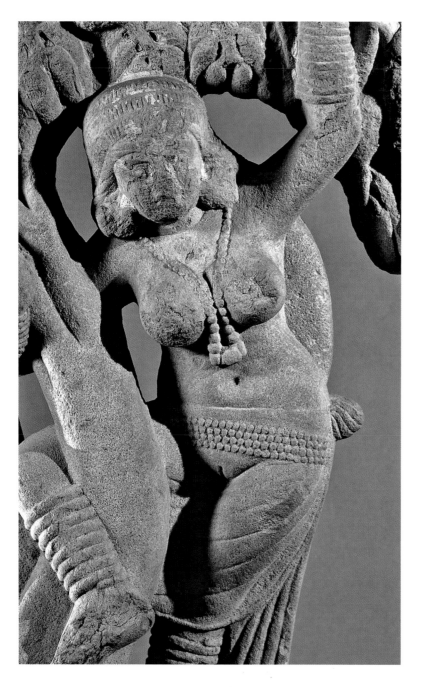

Shalabhanjika, supporting bracket from one of the gateways of the stupa at Sanchi. Sandstone, late 1st–early 2nd century.

The *shalabhanjika*, a tree spirit, is one of the most popular themes in Buddhist, Jaina and Hindu art. A young, scantily clad woman embraces the trunk of a tree with one leg and one arm, clutching the branches with her other arm. She is bedecked with a profusion of ornaments: bracelets cover her arms to her elbows and heavy anklets adorn her legs up to the knees. Probably derived from the ancient practice of tree worship, in which it was believed that a young virgin could make a tree blossom by the mere kick of her foot or simply touch a branch to make it flower, these sensuous female representations are thought to protect buildings and ensure the fertility and well-being of the whole community.

The tree under which the young woman stands is in full bloom. Her figure, with round breasts and full hips elegantly bent, is draped in a diaphanous garment through which her pubic area is clearly visible. Her hips are adorned by an elaborate beaded belt, a necklace hangs between her breasts and her arms and legs are covered with bracelets. The heavy earrings that hang from her ears are almost covered by the weight of tresses flowing down her back.

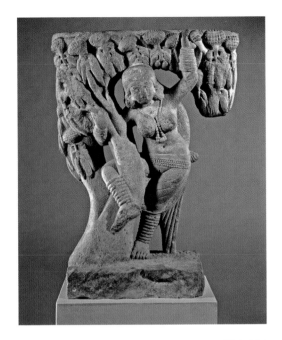

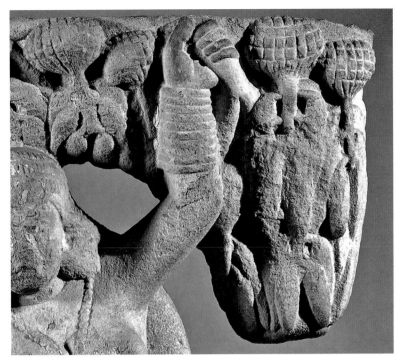

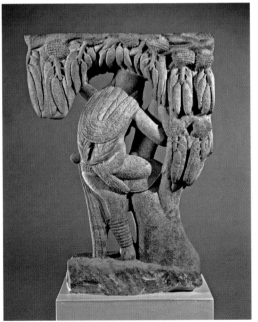

Revitalized by the embrace of the *shalabhanjika*, the tree bursts out in a spectacular display of fronds and bloom. The lush foliage and spherical flowers mirror the sensuousness of her voluptuous body, stressing the magical link that binds the *shalabhanjika* to the renewal of nature.

Yakshas and foliage, doorjamb, Madhya Pradesh. Sandstone, mid 16th century.
The *yakshas*, or nature spirits, are ubiquitously present in Indian culture. Those depicted on this fragment of doorframe are gnome-like, rambunctious and express irrepressible vitality, fertility and *joie de vivre*. On the outer band of the doorframe one sits pensively, a second seems to be talking animatedly, while a third, unfortunately beheaded, carries a drum beneath his arm, ready to burst into song and dance. Noteworthy are the charm boxes hanging around their necks.

The *yaksha* sculpted in the lower corner of the inner band of the doorframe has a magnificent creeper with lush foliage and tendrils sprouting from his mouth and meandering along the doorjamb. *Yakshas* and tree nymphs, *shalabhanjikas*, were local village deities which were gradually absorbed into Buddhism, Jainism and Hinduism. They presided over fertility and famine, health and disease, and as such they played a major role in village life. They had to be humoured with offerings and their wrath was the source of natural disasters. Here the connection with fertility has been visually expressed.

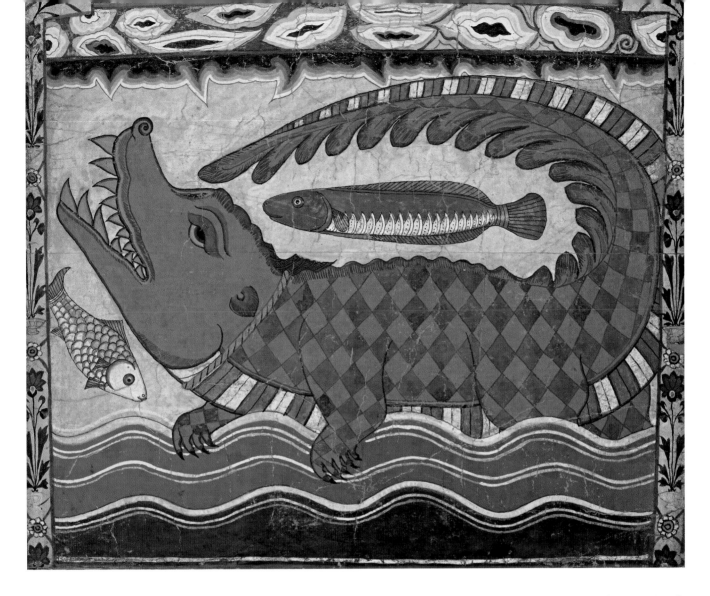

Crocodile, scene from a Gazi *pata*,
Murshidabad district, West Bengal.
Opaque watercolour on paper, 19th century.

Water and aquatic life is the theme of this charming register from a painted scroll. A crocodile with sabre-like teeth and alert eyes swims happily in the river. Around his scaly neck he wears a collar or necklace. His arched, almost serrated tail bends elegantly above his back, its tip touching his forehead. Two fish complete the tableau. The artist's almost abstract rendering of the sky with floating clouds counterbalances the elegant, sinuous movement of the river's waves.

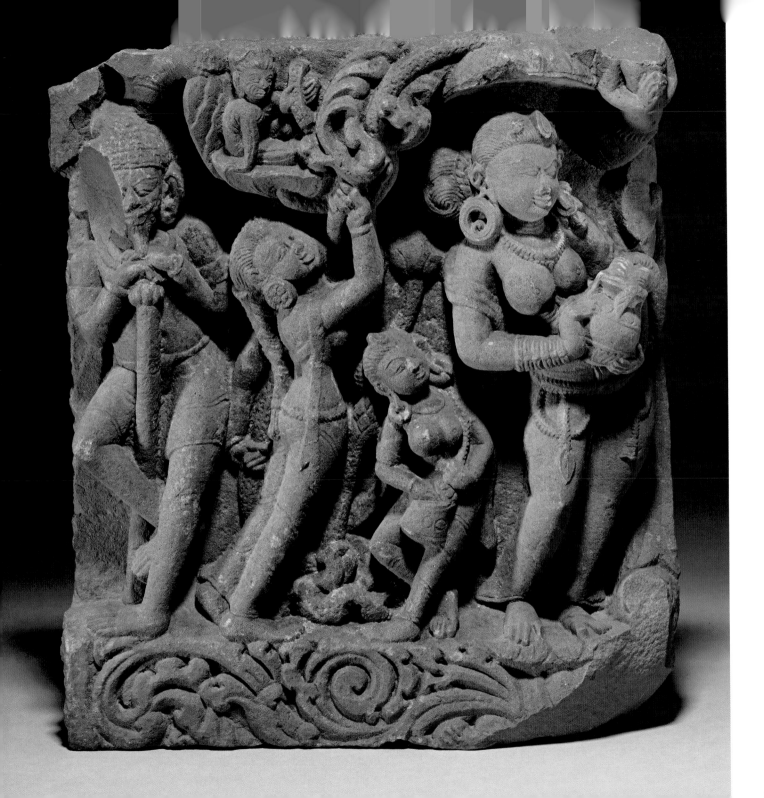

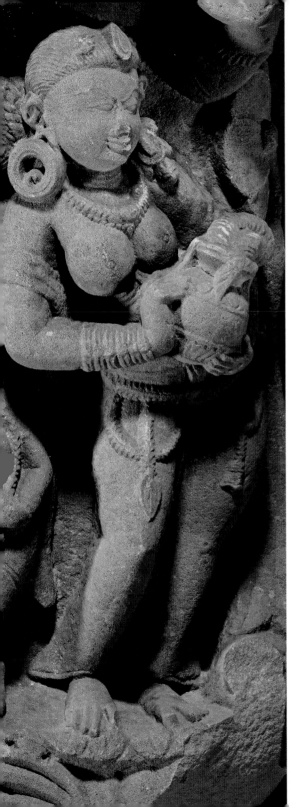

Ganga, fragment of a doorjamb, northern Rajasthan.
Sandstone, 10th century.

Elegantly standing on her vehicle, the *makara*, a fabulous animal similar to a crocodile with a lush, foliated tail, the river goddess Ganga, the personified Ganges, carries a pot full of water. Behind her is a diminutive attendant followed by a female parasol-bearer and a sturdy gatekeeper leaning with both hands on a long staff. An ascetic carrying a book is shown floating on the cloud above the parasol-bearer. On the opposite doorjamb there would have been a similar group accompanying the river goddess Yamuna, the personified Jumna, standing on her conveyance, the tortoise. Images such as these were carved at the entrances of sacred precincts: the river goddesses Ganga and Yamuna depicted on the doorjambs ensured that the visitor would have been symbolically purified by their water before entering the consecrated area.

Ganga, the personification of the sacred river Ganges, is always shown as a beautiful and bountiful woman. She was brought down from heaven, where she was flowing, by the rigorous austerities of King Bhagiratha, whose ancestors had been burnt by the wrath of a sage and whose ascent to heaven was dependent on their ashes being bathed in Ganga's water. Reluctantly, the goddess condescended to come down from heaven. Because she was self-willed, when she decided to flow on earth she summoned all her strength, so that her onrush would have crushed the whole earth had Shiva not intercepted her violent descent. She was trapped in his long matted hair, where she meandered for a long time before flowing first to earth and then to the nether world, where the ashes of King Bhagiratha's ancestors were finally purified. The goddess eventually became Shiva's wife and his liquid, cooling *shakti*, or energy.

The goddess Durga on her lion, Karnataka, possibly Mysore district. Brass and silver, 18th–19th century.

This small yet extremely powerful image, probably used for domestic worship, shows the climactic scene of the long story of Durga and Mahisha, the buffalo *asura*, one of the gods' most dangerous enemies. After a series of battles in which, through his magic skills, he constantly changes shape, Mahisha is at last defeated. Here, as he emerges from the decapitated carcass of a buffalo, he is grabbed by his long hair and transfixed by Durga's invincible trident. Great care has been lavished on the rendering of the ten-armed goddess and the attributes she holds in her hands. Particularly sumptuous is the framing arch culminating in a *kirttimukha*, beneath which is the five-headed cobra shading the head of the goddess.

It is believed that not only human beings need protection from evil, but also images and buildings. The artists devised a series of auspicious motifs to attract positive influences and avert negative ones. One of the most common is the *kirttimukha*: a lion face with bulging eyes and an open mouth filled with sharp fangs, spewing garlands. It is found in jewellery, on the arched frames surrounding metal images, and in various parts of sacred buildings, especially above images.

With a violent thrust, the goddess Durga pulls the *asura* out of the buffalo's carcass by the hair. The head of the buffalo lies near her lion's paw.

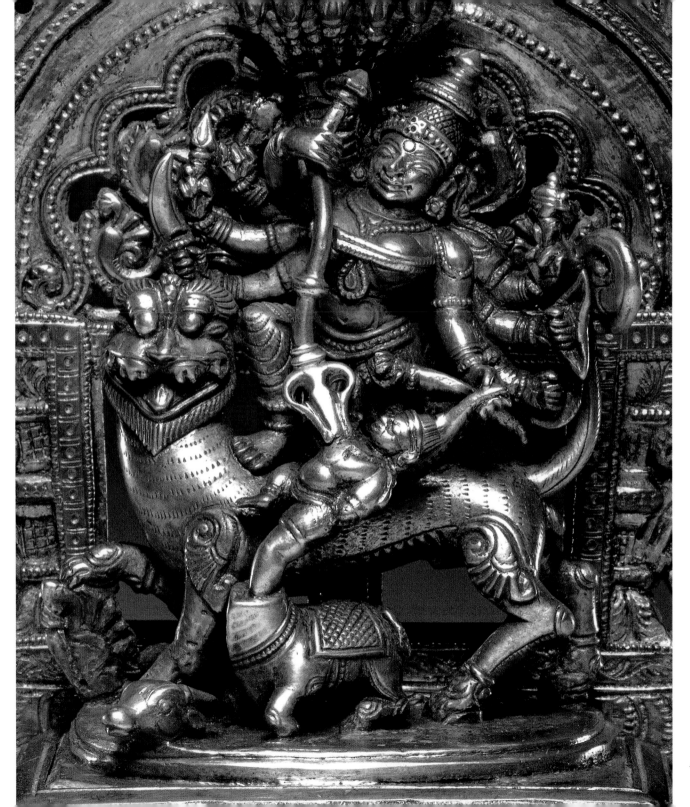

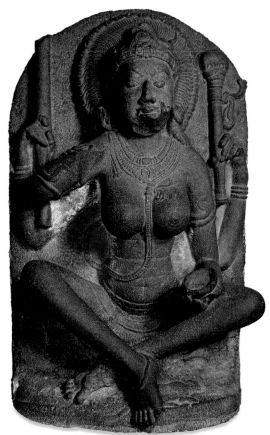

The goddess Chamunda, northern Tamil Nadu, perhaps Kanchipuram. Granite, 9th–10th century.

This powerful image was probably one of a series depicting the seven mothers, a group of goddesses who appeared around the middle of the first millennium and whose iconography was standardized shortly after. Among them is the redoubtable goddess Chamunda, a form of the goddess Kali, born from Durga's wrath. Her beautiful and graceful body contrasts sharply with her wild hair, fierce face and attributes: a skull-topped staff and a skull-cup, which indicate her awesome nature.

The most conspicuous characteristics typical of fierce deities are exemplified here: dishevelled hair, round bulging eyes, knitted eyebrows and small fangs protruding from the mouth. Particularly impressive is the rendering of the hair, which looks like a crown of flames emerging from the goddess' head. A snake slithers towards the top of her head.

The goddess Chamunda, Orissa. Sandstone, 8th century.

In eastern Indian iconography, emphasis is laid on the skeletal appearance of the goddess: her skull-like face and sinewy neck, her prominent rib cage, pendulous breasts, sunken belly and emaciated legs. In her eight arms she carries a number of weapons, a severed head and a skull-cup. Her ornaments are made of corpses, skulls, snakes and bones. She sits on a supine figure on which perch two birds.

The goddess Chamunda symbolizes delusion or malignity. Her gaunt, skull-like physiognomy is dominated by her bulging eyes, which stare out of their sockets, and her enigmatic grin, possibly expressing awareness that the whole of creation is a mere illusion.

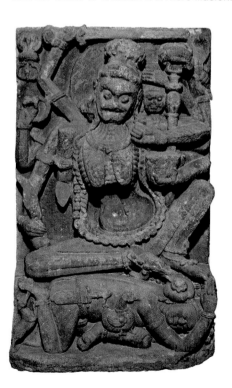

A supine youth, armed with a dagger, lies with a leg flexed beneath him, on which a goose(?) perches. On his head is Chamunda's conveyance, the owl.

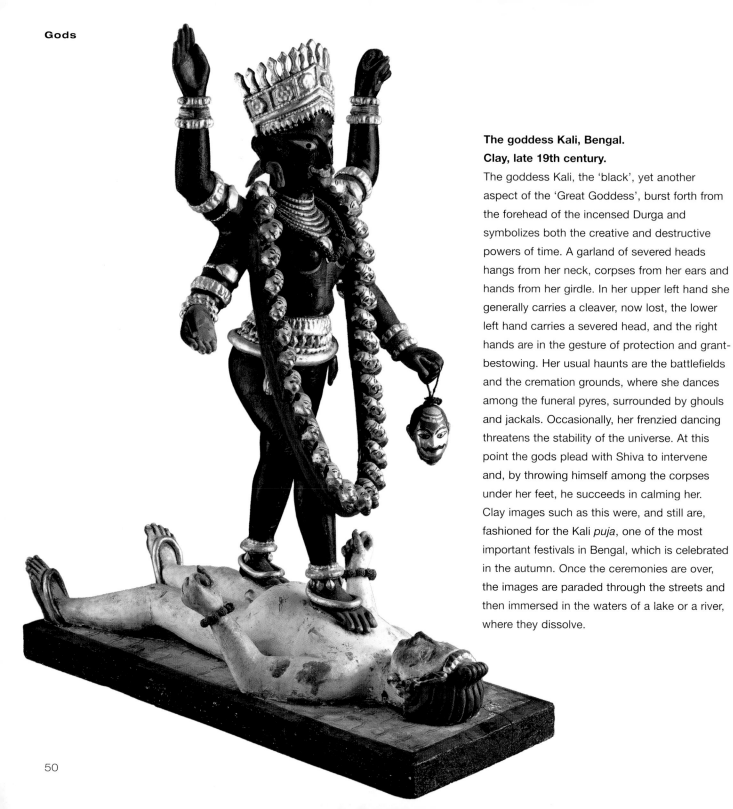

The goddess Kali, Bengal.
Clay, late 19th century.

The goddess Kali, the 'black', yet another aspect of the 'Great Goddess', burst forth from the forehead of the incensed Durga and symbolizes both the creative and destructive powers of time. A garland of severed heads hangs from her neck, corpses from her ears and hands from her girdle. In her upper left hand she generally carries a cleaver, now lost, the lower left hand carries a severed head, and the right hands are in the gesture of protection and grant-bestowing. Her usual haunts are the battlefields and the cremation grounds, where she dances among the funeral pyres, surrounded by ghouls and jackals. Occasionally, her frenzied dancing threatens the stability of the universe. At this point the gods plead with Shiva to intervene and, by throwing himself among the corpses under her feet, he succeeds in calming her. Clay images such as this were, and still are, fashioned for the Kali *puja*, one of the most important festivals in Bengal, which is celebrated in the autumn. Once the ceremonies are over, the images are paraded through the streets and then immersed in the waters of a lake or a river, where they dissolve.

Although the goddess Kali is traditionally represented as a gaunt old woman devouring all beings, she is here shown as a handsome young woman wearing a crown of typical Bengali design. However, despite her alluring appearance, a number of details including her ornaments, made of severed hands, heads and corpses, reveal her awesome personality. Her dark complexion suggests the dissolution of individuality in the timeless darkness which is filled with the potential for new life. Her nakedness symbolizes the stripping away of the illusions in which life is entangled.

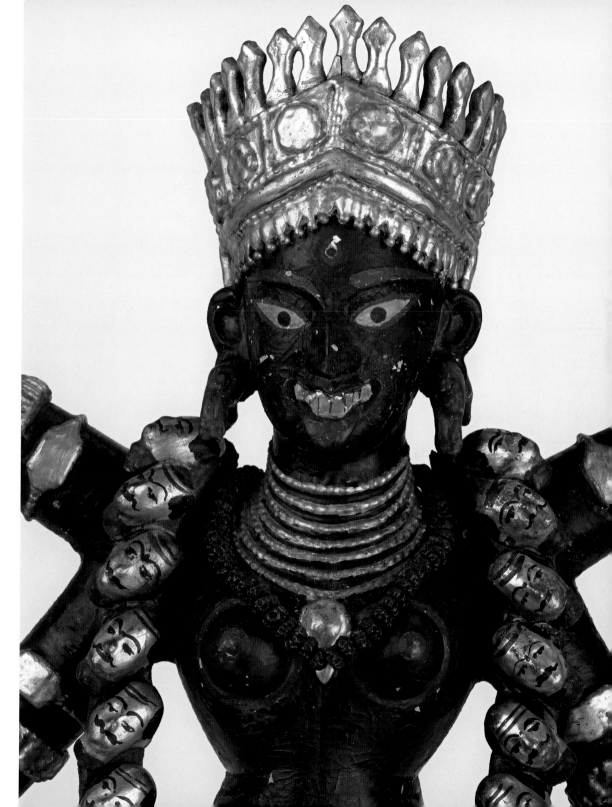

Rahu, Konarak, Orissa. Schist, 13th century.
This sculpture is one of a series that shows the *navagrahas*, nine planets. The planets play a pivotal role in Indian culture because they are believed to influence the life of the individual. Great care is taken to propitiate them, especially in critical and dangerous times. Rahu is responsible for eclipses. When the nectar of immortality was retrieved from the depths of the sea, Rahu appeared disguised as a god and sat among the other deities waiting for his share of nectar. He was spotted by the gods of the sun and the moon, Surya and Soma, and they informed Vishnu, who decapitated Rahu with his discus. However, since Rahu had already swallowed a few drops of the nectar, he became immortal. Since then his head has circled the sky, chasing the sun and moon. He is shown as a fiercely countenanced half-man. In his hands are two crescents, probably symbolizing the sun and the moon. In Indian astronomy Rahu is identified with the ascending node of the moon, while his tail is identified with Ketu, the descending node. In astrology, Rahu *kala*, Rahu's time, is an inauspicious period that occurs daily at different hours, when it is advisable to avoid new or difficult enterprises.

Rahu exhibits all the iconographic characteristics of an awesome deity: dishevelled hair (here shown as a mane of curly locks escaping from a crown, adorned with round elements displaying a lion face); bulging round eyes; knitted eyebrows; bushy moustache and an open mouth with protruding fangs. Rahu's beard, like his hair, is elegantly curled and also knotted at its tip. Huge round earrings and necklaces complete his attire.

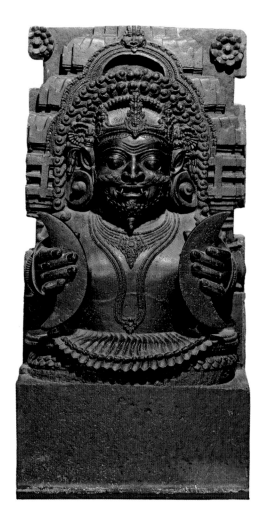

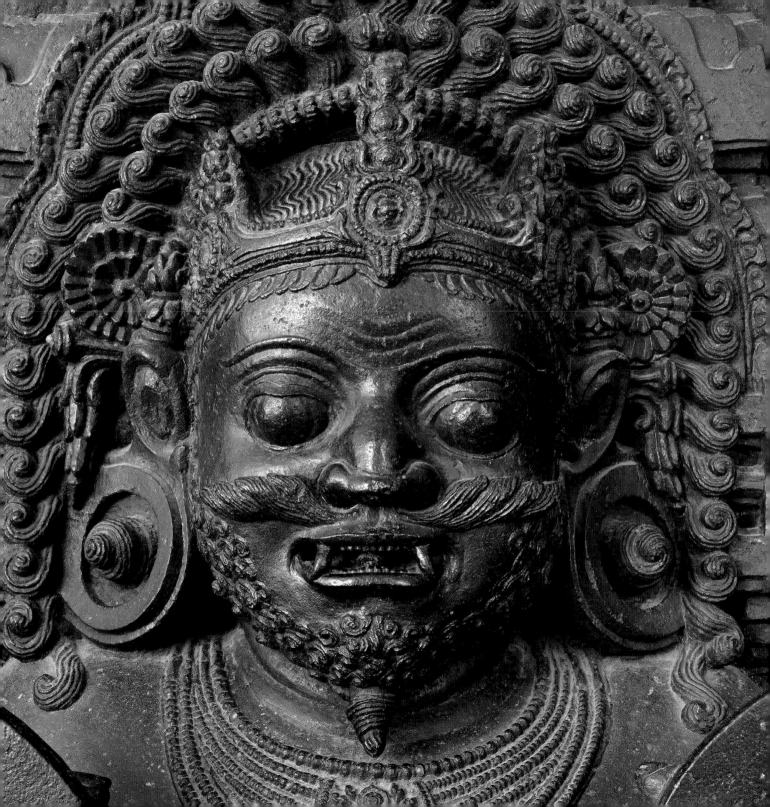

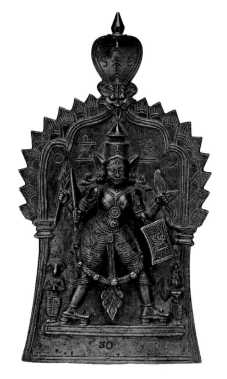

**Virabhadra, Karnataka, perhaps Mysore district.
Bronze, 18th century, or earlier.**

This metal plaque, showing the four-armed Virabhadra, an emanation of Shiva's wrath, was acquired before 1810, the date in which it was reproduced in Edward Moor's pioneering work, *The Hindu Pantheon*. This was one of the first books to attempt a systematic presentation of the gods of the Hindus to the British public. The plaque has a scalloped upper edge from which issue stylized flames, and it is surmounted by a cobra emerging from a lion's head. Virabhadra carries in his upper right hand an arrow, in his upper left a bow, and in the lower hands are a sword and shield. He wears a crown, a dhoti and toe-knob sandals. Among his jewellery is a long wreath adorned with skulls. Two diminutive figures flank him: the ram-headed Daksha, with hands in *anjali mudra*, and the goddess Bhadrakali, with a flower in her hand. Plaques like this are either worn by mendicants or carried in their begging bowls.

Virabhadra, a popular deity in southern Maharashtra and Karnataka, was created by Shiva to destroy the great sacrifice that his father-in-law, the patriarch Daksha, had organized without inviting Shiva. Although Shiva did not resent the snub, his wife Sati, Daksha's daughter, was inconsolable and in her distress attended the sacrifice only to jump into the fire. The irate Shiva then created Virabhadra, who not only destroyed the sacrifice but also beheaded Daksha. Virabhadra is usually shown as a young warrior, armed and ready for action. Flanking his head are a *linga* and a crouching Nandi, two of the most popular Shaiva emblems. The sun orb and the moon crescent suggest that the fame of Virabhadra will last as long as the sun and the moon.

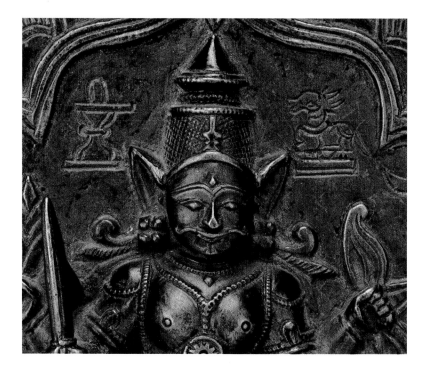

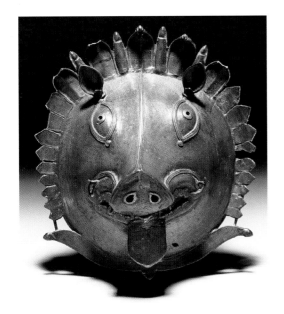

Mask of Panjurli, south Kanara district. Bronze, 19th century.

Alongside Buddhism, Jainism, Hinduism and other religions, a number of regional cults have survived. One of these is the Bhuta or spirit cult of the Tulu-speaking region of south Kanara, on the southwestern coast of India. Although this is probably a very ancient cult, the first written references to it date from around the 16th century. This bronze mask shows Panjurli, the boar spirit, who is one of the most important. He appears in a variety of guises, from a raging wild animal which devastates the earth with its tusks to a princely deity riding on a boar. The elongated boar's face is surrounded by what looks like a halo of lotus petals. The mask is worn either fastened on the head or over the face of the person impersonating the deity during the annual festivals.

Viewed in profile, the mask – with its sharp, curved tusks emerging at the sides of the slightly open mouth, bared teeth and protruding tongue – conveys in its stark simplicity the awesome nature of the boar spirit Panjurli.

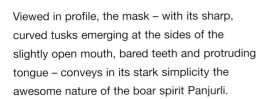

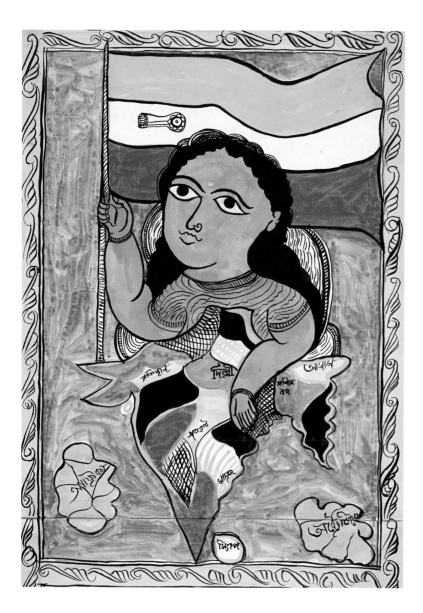

**Indira *pata*, 12-scene painted scroll
by Ajit Chitrakar of Theakuachack village,
Midnapore district, West Bengal.
Opaque watercolour on paper, 1986.**
Not only gods, goddesses, saints and other
supernatural beings but also politicians find their
rightful place in the ever evolving mythology of
India. This 12-scene scroll narrates the eventful
life of Mrs Indira Gandhi.

**The bust of Mrs Indira Gandhi emerges
out of the map of India.**
This arresting image, celebrating the apotheosis
of Mrs Gandhi, opens the scroll. She emerges,
the Indian flag in her right hand, from a map of
India, which incidentally also includes Sri Lanka,
Africa and Australia. This probably signifies that
her political influence stretched well beyond the
Indian borders. In the mind of the painter, the
two representations of Bharat Mata, Mother
India – generally shown either as a map of India
or as a young crowned woman carrying a flag in
her hand – have coalesced. In giving Bharat
Mata the features of Mrs Gandhi, he implies that
the goddess and the politician have merged.

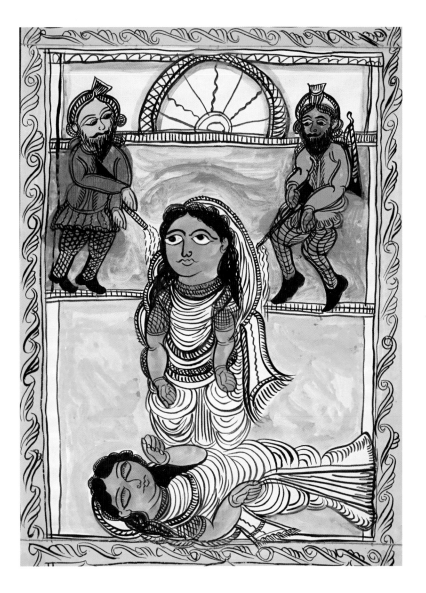

Mrs Indira Gandhi is gunned down by her Sikh bodyguards.

From the upper corners of the frame, two diminutive Sikh bodyguards shoot a rain of bullets on Mrs Gandhi. At the centre of the composition is her towering figure, draped in a sari whose headpiece covers her head, and her wide-open eyes stare out of the picture. At the bottom of the frame she lies dying, with her eyes closed. Above the standing figure of Mrs Gandhi is a semi-circular fanlight, as often seen above the doors of early 20th-century buildings.

3

Heroes

Most works of Indian art draw their inspiration from the stories narrated in the two great Sanskrit epics, the *Mahabharata* and the *Ramayana*, as well as the Puranas ('old stories'), which are anthologies of ancient myths. This literary corpus is very important: through the epics and the Puranas the principles of religion and ethics are disseminated among those who would otherwise have no access to the Vedic tradition: the lower classes of society, women and the illiterate.

The *Mahabharata* ('the great Bharata'), possibly the longest poem in the world, whose reputed author is the mythical sage Vyasa, was probably compiled between the 3rd century BC and the 4th century AD. At its core is the narrative of a rivalry between two related families, the Kauravas and the Pandavas, for the conquest of the land of Bharata, Upper India. The years of rivalry culminate in a fierce battle lasting 18 days, from which the five Pandavas emerge victorious. After some time, however, sorrow and remorse descend upon them, and Yudhishthira, the eldest, determines to abdicate. He retires to the Himalayas, accompanied by his brothers and their common wife, Draupadi. During their

Babhruvahana, son of Arjuna, kills Prativeda.

journey all die, one after another, except Yudhishthira, who undergoes various ordeals. Eventually all are admitted to Indra's paradise. Interwoven with this simple narrative are numerous myths, teachings, folk tales and lengthy theological, ethical and philosophical passages. Among these is one of the most famous religious texts in the world: the *Bhagavadgita*. Over the years countless poets and editors from diverse schools of thought have tampered with the original text, so that occasionally contradictory doctrines coexist within this extraordinary work.

The *Ramayana* ('Rama's career'), the second great Sanskrit epic poem, is believed to be the work of the mythical sage Valmiki. It was probably composed between the 4th century BC and the 3rd century AD and narrates the adventures of Rama, beloved son of King Dasharatha, who is banned from the kingdom of Ayodhya as a result of the intrigues of his father's youngest wife. Accompanied by his own wife Sita and his brother Lakshmana, Rama goes into exile in the forest. In these wild surroundings the trio have numerous adventures, culminating in the abduction of Sita by Ravana, king of Lanka. With the help of the King of the Monkeys and, in particular, of the great monkey-hero Hanuman, Ravana is eventually defeated and killed, and Sita is rescued. To prove she has

remained chaste and faithful to Rama during her long imprisonment in Ravana's palace, she undergoes an ordeal by fire and emerges unscathed from the flames. Rama, Sita and their followers then return to Ayodhya, where Rama is crowned. Soon after, however, public doubts are cast on Sita's chastity, and Rama – putting his kingly duty before his own and Sita's personal happiness – decides he must ban her from his kingdom. His action triggers a sequence of tragic events which overshadow the final years of his life.

The Puranas are vast collections of myths, ranging from the creation of the universe, its destruction and recreation to the genealogies of various gods and the histories of mythical dynasties. As in the case of both the epics, the narratives in the Puranas are interspersed with passages on extremely disparate subjects: theology, philosophy, science, ritual, astrology, architecture, iconography and much more. Written in Sanskrit verse, the text takes the form of a dialogue between a sage, the main narrator, and his inquisitive disciples, who raise a number of questions. There are 18 major and 18 minor Puranas, the oldest of which is dated *c.* 6th century AD. One of the most important is the *Bhagavata Purana*

(*c.* 9th–10th century), which focuses on the life of Krishna. This work, a pivotal text for understanding the Krishna cult, is extremely popular. Often recited and discussed, it has provided constant inspiration for the arts. Interestingly, Dadasaheb Phalke (1870–1944), a legendary film director, is credited with having started the Indian film industry with his *Raja Harischandra* (1913), a story drawn from puranic lore. Ever since, an important branch of the Indian film industry has specialized in the production of so-called 'mythological' films. Innumerable films have been inspired by the *Ramayana*, but R. Sagar's televised version of 1986–8, which was broadcast every Sunday morning, famously brought the entire subcontinent to a standstill for an hour. Films based on the *Mahabharata* have also achieved box office success and, in the wake of the *Ramayana*, R. and B. R. Chopra produced a version of the *Mahabharata* for Indian television (1988–90). The universal appeal of this text, a story about the human condition for all mankind, inspired the British director Peter Brook to present the *Mahabharata* to Western audiences in a nine-hour staged performance, which was subsequently abridged as a film (1989).

The death of Prativeda.

59

RIGHT: Indian culture has created a whole mythology around ascetics and seers who seek spiritual emancipation as a means of breaking the endless cycle of death and rebirth. Having renounced the world, they live in the wilderness and undergo the most extreme penances to attain spiritual freedom, supernatural wisdom and magical powers. While they are great teachers, poets and thinkers, they can be notoriously difficult characters.

Scenes from the Ramayana, Tamil Nadu or Sri Lanka. Painted cloth, *kalamkari*, early to mid 19th century.

This long cloth, 7.46 metres long and 1.08 metres wide, illustrates events which occurred when Rama, his wife Sita and his brother Lakshmana were exiled from Ayodhya. They wandered through jungles, crossed rivers, fought against a number of anti-gods and visited several ascetics, who imparted useful knowledge. The narrative stops abruptly with Sita's abduction by Ravana. This cloth may have been part of a set illustrating the whole *Ramayana*. Each scene bears a short caption in Tamil.

BELOW LEFT: Boat on a river.
BELOW: Ascetics performing fire oblations on a mountain.

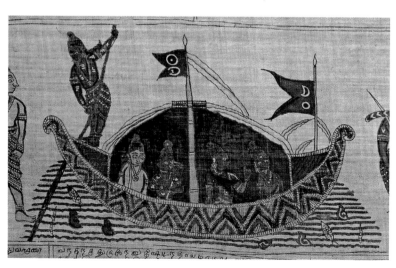

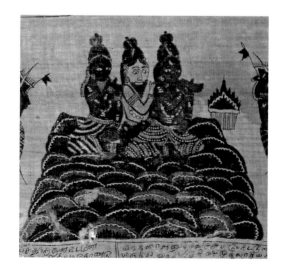

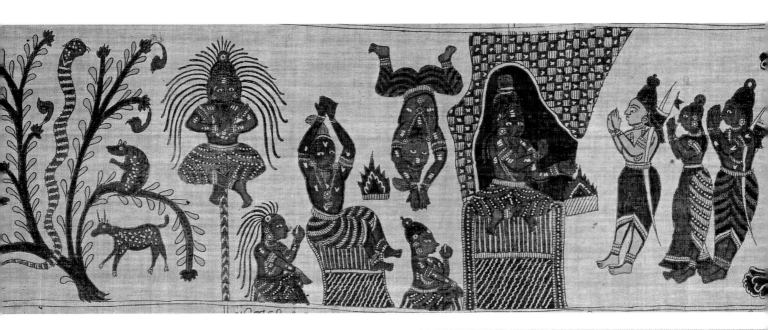

RIGHT: After having
been mutilated by
Lakshmana, Rama's
brother, Shurpanakha
runs to her brother
Ravana, the
10-headed, 20-armed
king of Lanka, and
subtly persuades him
to abduct Rama's
wife Sita in revenge.

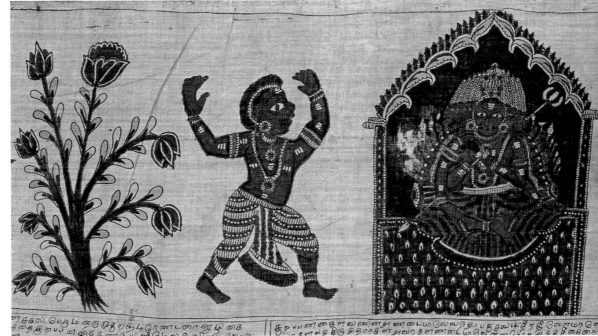

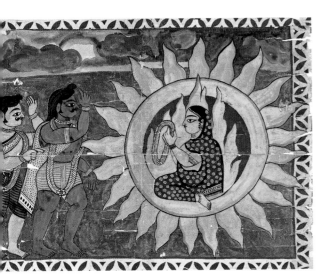

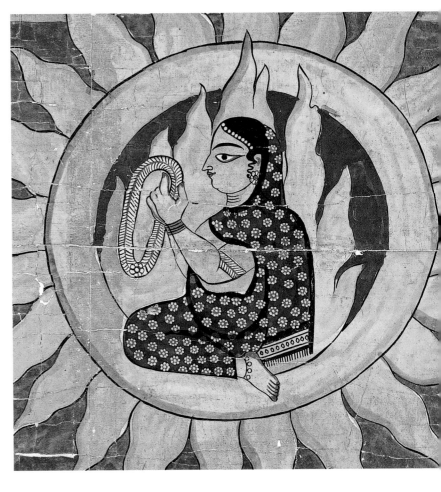

Sita's fire ordeal, scene from a Ramayana scroll from Bishnupur, Bankura district, West Bengal. Opaque watercolour on paper, 19th century.

This is a striking rendering of one of the most dramatic episodes of the *Ramayana*. Rama and Lakshmana look on, with one hand uplifted in amazement, while Sita undergoes the fire ordeal to prove her chastity. There is no doubt, here, that the sympathies of the artist lie with Sita, the main figure in the painting, engulfed by tongues of fire and surrounded by a halo of flames.

Sita, dressed in a sari demurely covering her head and carrying a garland in her hands, sits in the flames. Her calm and composed attitude is enhanced by the vivid depiction of the fire which engulfs her, yet miraculously leaves her unscathed. The sun-like halo of flames surrounding her may suggest her divine nature.

**Rama and his brother Lakshmana,
Tamil Nadu. Ivory, 16th–17th century.**

Although Rama – like Krishna – is an *avatara* of
Vishnu, he has gradually become a deity in his
own right and the focus of intense devotion.
He is celebrated as the perfect son, brother,
husband and king, as well as the epitome of
righteousness.

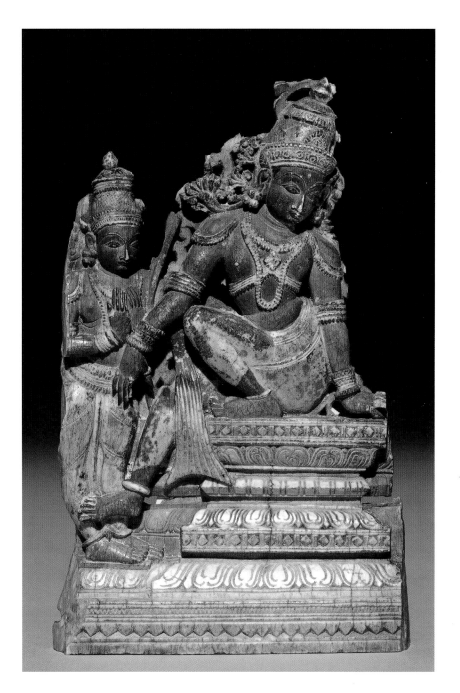

This fine ivory, possibly a fragment of a larger
item such as a casket or a throne, depicts Rama
and his faithful brother, Lakshmana, after Sita's
abduction. Rama sits in a despondent mood
looking down, while Lakshmana stands at his
side with hands folded in *anjali mudra*, a bow
slung over his shoulder. Rama's face reflects the
ideals of adolescent beauty: delicate lineaments,
beautifully arched eyebrows, eyes shaped like
a lotus petal, a pointed nose and small chin.
On the neck three – or more – folds denote a
healthy young person. Elaborate earrings adorn
his ears, and on his head is a tiered and
bejewelled crown, decorated with flowers.

Episodes from the Mahabharata, probably from Kalahasti.
Painted cloth, *kalamkari*, depicting the *Virata parva*, *c*. 1890.
The term *kalamkari* means 'pen-workmanship' and designates hand-painted
resist and mordant-dyed cotton cloths. This complicated technique
involved a combination of printing and dyeing together with direct painting.
Kalamkaris were produced on the Coromandel coast and in the region of
Surat, in Gujarat, and they were in great demand in the West as well as in
Southeast Asia.

This large cloth, measuring 3.30 by 3.37 metres, depicts the events
narrated in the *Virata parva* of the *Mahabharata*. The narrative proceeds
from left to right, and each scene bears an explanatory caption in Telugu.
The eldest of the five Pandava brothers, Yudhishthira, was selected by his
uncle to succeed him, in preference to his own sons, the Kauravas. This
caused the old feud between the two families to flare up. The Kauravas
invited Yudhishthira to gamble his kingdom, his riches, his brothers and
their common wife, Draupadi, in a game of dice. The terms of the wager
were that the loser would spend 12 years in exile in the forest, and remain
incognito for a further year. The loaded dice ensured that Yudhishthira lost
and was exiled with his brothers and Draupadi. Here are narrated the
adventures of the five Pandava princes and their common wife when they
lived under false identities at the court of King Virata.

The central medallion depicts the reclining image of Shri Ranganatha in
the temple of Srirangam. There are scenes in the squinches above: the
two at the top illustrate the climax of Vishnu's incarnation as the man-lion
Narasimha. The two at the bottom show the heavenly minstrels, Narada
and the horse-headed Tumburu.

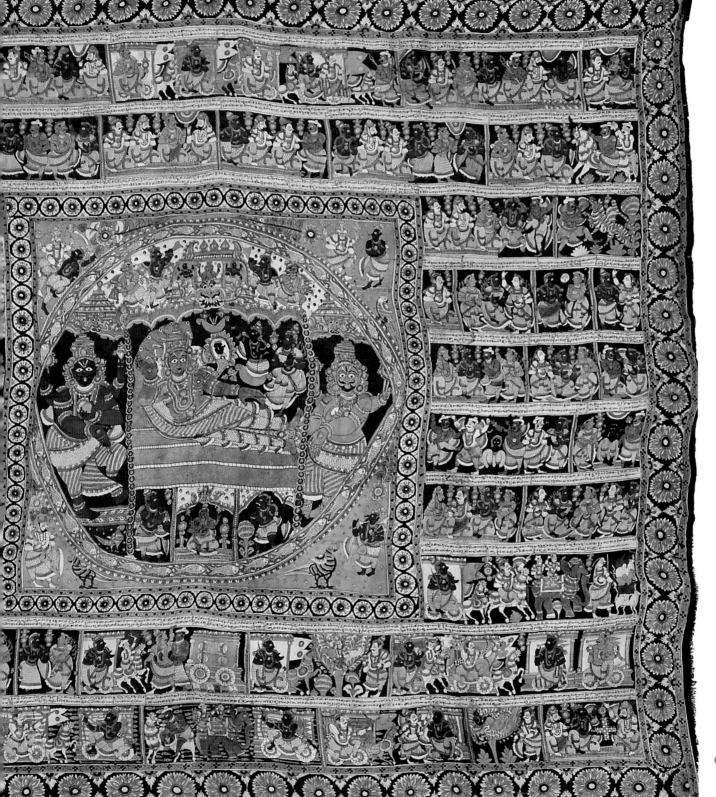

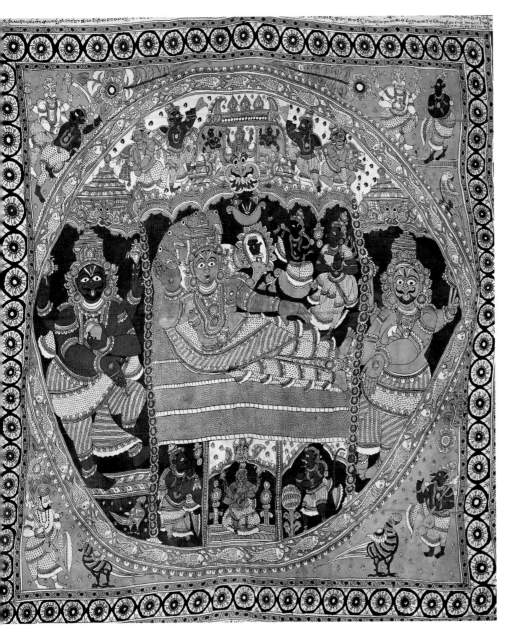

Shri Ranganatha enshrined at Srirangam, probably from Kalahasti. Central tableau from a large painted cloth, *kalamkari*, depicting the *Virata parva*, *c.* 1890.

On the island of Srirangam, surrounded by the river Kaveri filled with aquatic life, is the temple dedicated to Shri Ranganatha, an aspect of Vishnu. This tableau depicts the image enshrined in the sanctuary: Shri Ranganatha lies on the coils of the five-headed snake, the *naga* Shesha. At his feet is his consort, the goddess Ranganayaki, and floating on a cloud above him is the dark-skinned Vibhisana, one of his great devotees. Behind the reclining god is a lotus on whose pericarp sits a diminutive four-headed Brahma, above whom, supported by a cloud, are the emblems of the deity: the discus, the *namam*, and the conch. Two huge *dvarapalas*, guardians, stand at the entrance to the sanctuary. Above the main image are the elaborate roofs of the temple, above which float *gandharvas* singing, blowing trumpets and strewing flowers. Beneath the reclining image, flanking a seated Vishnu in a smaller shrine, stand Vishnu's conveyance, Garuda, and Rama's devotee Hanuman, both with hands in *anjali mudra*.

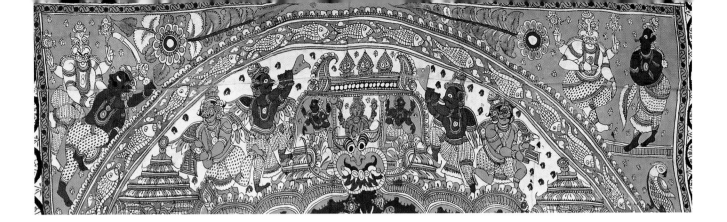

Three elaborate towers soar above the temple of Shri Ranganatha. The central and tallest one is embellished with pinnacles and foliage-like architectural elements. On it, emerging behind the forehead of a *kirttimukha* with bulging eyes, horns and ferocious mouth, is the image Paramavasudeva, the sublime aspect of Vishnu, flanked by guardians. In the sky *gandharvas* play trumpets and empty baskets of flower petals on the sacred image. In the squinches, to the left, the four-armed Narasimha has just caught Hiranyakashipu, who vainly attempts to flee, brandishing his sword. To the right Prahlada, the son of Hiranyakashipu and staunch devotee of Vishnu, worships the god, who was incarnated as a man-lion to protect him from his father.

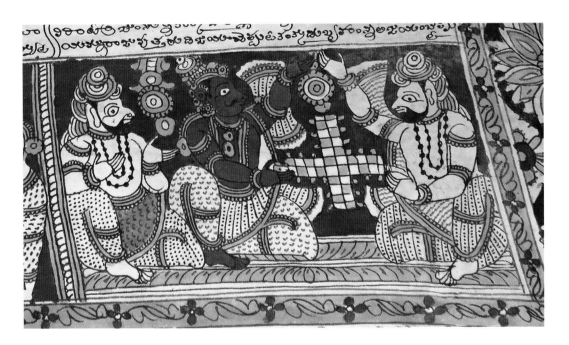

King Virata and Yudhishthira, in the guise of a Brahmin, play *pachisi*. The cross-shaped, oversized board serves as a dramatic reminder of how Yudhishthira gambled away his kingdom and family, after which the Pandavas and their common wife lived under false identities at the court of Virata.

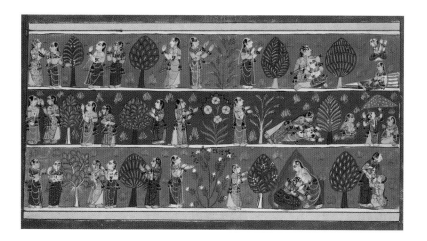

**In search of Krishna, illustration to the
Bhagavata Purana, Malwa.
Opaque watercolour on paper, *c.* 1690.**
Divided into three horizontal registers, this
vibrant painting depicts the pangs of separation:
the lovelorn milkmaids, the *gopis*, wander
through the forest in search of Krishna, who has
mysteriously vanished. In their bewilderment
they ask the trees and the shrubs of the forest if
they, perhaps, have seen Krishna. Failing to find
him, they re-enact his exploits.

One of the *gopis* (top register) takes the part of Yasodha,
Krishna's foster mother, and nurses another *gopi*, who plays
Krishna's part.

The *gopis* ask one another whether any of
them have seen Krishna. Their stance and
gestures express their bewilderment. The
tree at the centre of the group suggests
the forest.

A *gopi*, standing before a flowering shrub, asks whether its flowers have bloomed because of Krishna's touch. Bees hovering around flowers are a common metaphor for the union of lovers.

Proudly re-enacting the lifting of Mount Govardhana on the little finger of her left hand, this *gopi* shelters two of her companions beneath it.

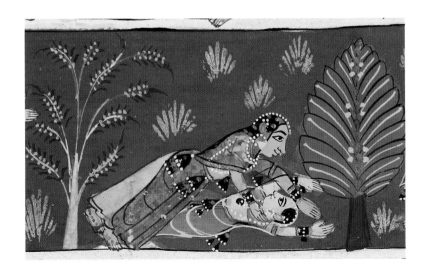

In the second register a *gopi* impersonates Putana, the demoness who was sent by King Kamsa to kill Krishna with her poison-smeared breasts. She is depicted here lying lifeless on the ground, while the *gopi*, impersonating the infant Krishna, crawls on top of her.

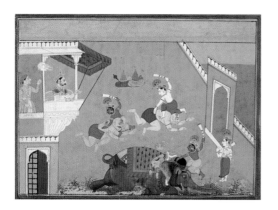

Krishna and Balarama in Mathura, illustration to the *Bhagavata Purana*, Mewar. Opaque watercolour on paper, *c*. 1720.
The arrival of Krishna and Balarama at Kamsa's court in Mathura is a turning point in their story. Their victory over the mad elephant, the prize fighters and finally the killing of Kamsa close the bucolic phase of their career and usher in Krishna's life as head of the Yadava clan, statesman and ally of the Pandavas in the *Mahabharata* war.

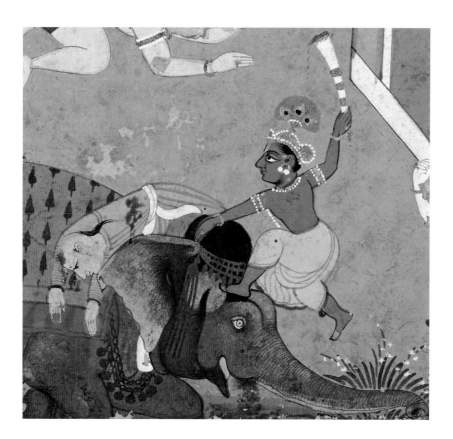

Without flinching, Krishna kills the mad elephant, sent by King Kamsa to destroy them. The helpless elephant lies dying on the ground of the arena. Krishna, armed with one of the animal's tusks, reduces the elephant's mahout to a bloody pulp.

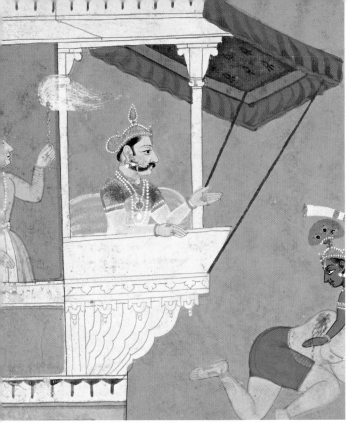

Kamsa, the tyrant of Mathura, sits comfortably on a balcony on the second floor of a mansion. The ruler is screened from the heat of the day by an awning. Behind him stands an attendant waving a fly-whisk. The king's gesture betrays his perplexity at the youths' unexpected prowess.

Armed with elephant tusks, Krishna and Balarama fight against Chanura and Mushtika, the king's champion wrestlers. The two slight youths effortlessly overwhelm the two sturdy men. In the background are the boys' clothes, removed before the contest.

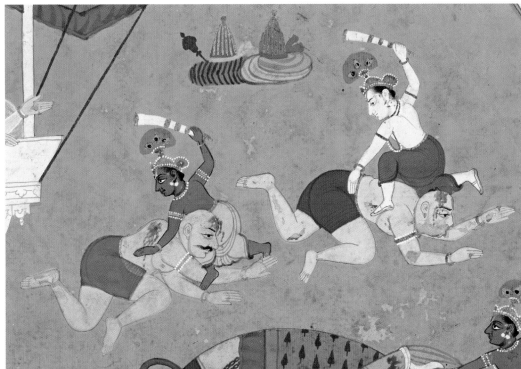

Bhavana *rishi* scroll, Telangana, Andhra Pradesh.

Painted scroll, pigments on cloth,

late 18th–early 19th century.

Literary sources from as early as the 2nd century BC testify to the existence of storytellers, and this cotton painted scroll from Telangana, part of modern Andhra Pradesh, bears testimony to this tradition. Scrolls, normally vertical in format, are about a metre wide and ten metres long. The narrative is arranged in 20 to 30 descending horizontal panels, separated from each other by narrow borders.

The subject matter of these scrolls is the origin and history of various castes: this one narrates the origin of the weavers' caste, the Padmasale. In the course of the performance, the scroll was hung on two bamboo or wooden poles and unrolled from the top. Members of particular caste groups, here the weavers, invited professional storytellers to recite the myths pertaining to their own caste. The narrative was in Telugu, part in verse and part in prose. Occasionally, as in this case, the scrolls were sold by the descendants of a deceased performer, if nobody of that family was inclined to follow in the picture-storytelling profession.

The hero of this story, Bhavana *rishi*, sits majestically on a superbly caparisoned and bejewelled tiger. Interestingly, the animal has eyebrows and a moustache instead of whiskers, which shade its growling mouth, uncovering its sharp teeth and a lolling tongue. Its sharp claws are carefully rendered. The hero brandishes a sword in his right hand, a bow is slung on his shoulder, a quiver bristles with arrows, and a dagger and buckler hang from his waist. He meets his opponent, a dark-complexioned, demon-like creature, who has a large sword in his hand and is mounted on a chariot drawn by two horses. Two of the demon's attendants shower a volley of arrows on Bhavana *rishi* and a third, daringly, sneaks beneath the tiger. A companion, armed with a small bow and flanked by a diminutive tiger, follows the hero. A sage carrying two peacock's feather fly-whisks floats on a cloud, unperturbed by the volleys of arrows criss-crossing the sky.

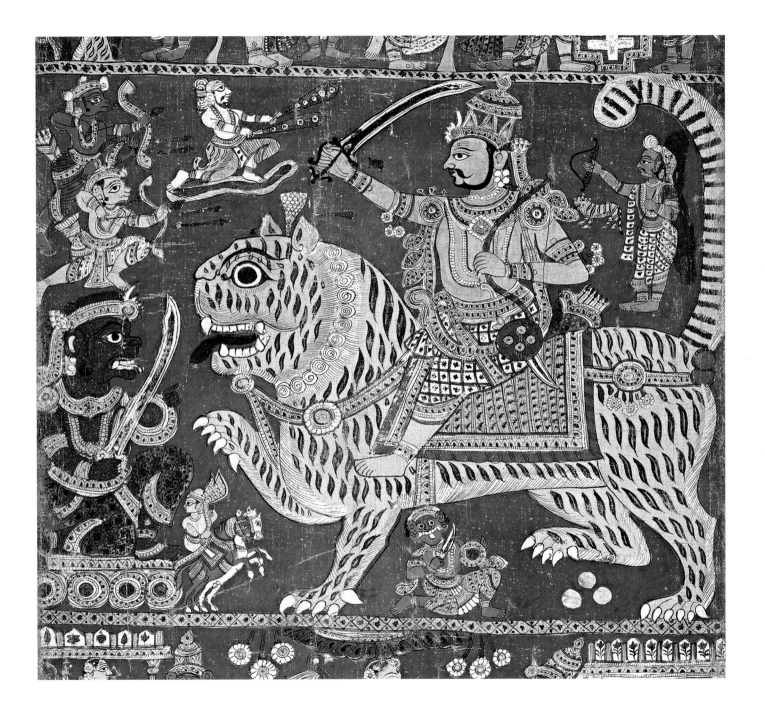

Bhavana *rishi* scroll, Telangana, Andhra Pradesh. Painted scroll, pigments on cloth, late 18th–early 19th century.

In the course of his wanderings, Bhavana *rishi* arrives in a fabulous forest where he sees hunters carrying dead animals suspended by the legs on a pole, or across their shoulders; a bird catcher with a peacock perched on his left shoulder; Narasimha extracting a thorn from the foot of Chenchu Lakshmi; a huntress nursing a child while firmly holding a snake in her hand. A magnificent mythical bird, the *gandabherunda*, carrying in its claws four elephants, two *yalis* and two snakes, occupies the centre of the register. All around, the forest is alive with animal life: prowling tigers and squirrels climbing up the trunks of the trees in whose crowns live a multitude of different birds.

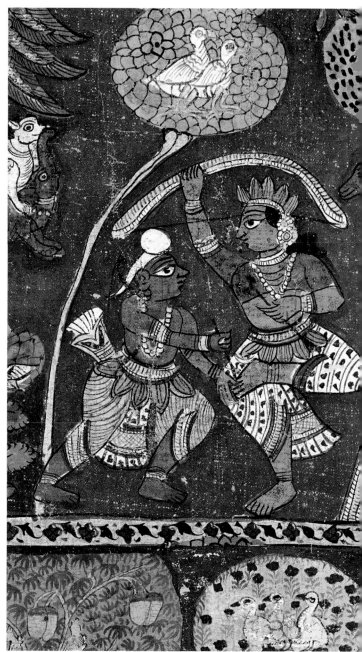

LEFT: According to a local legend from Andhra Pradesh, Narasimha met a lovely girl from the Chenchu community and fell in love with her. Her father, a Chenchu chieftain, put Narasimha through a series of tests, such as climbing tall trees, collecting wild honey, digging termite mounds and hunting. Having successfully passed these trials, he married the girl. Here Narasimha is shown extracting a thorn from the foot of Chenchu Lakshmi. She wears a leaf crown, a leaf belt, and stands elegantly lifting her bow, while Narasimha kneels at her feet. This is one of the most popular and frequently represented episodes of the story of Narasimha among the Chenchus.

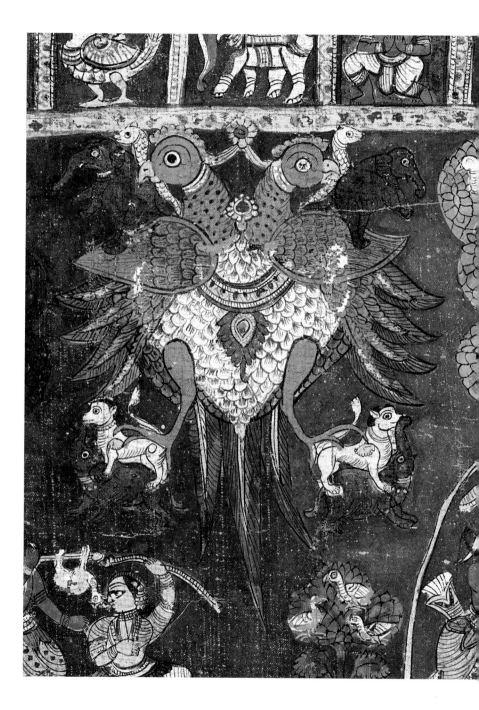

RIGHT: Among the many fabulous beasts of Hindu mythology is the *gandabherunda*, whose name means 'having terrible cheeks'. This fierce two-headed bird, whose history is not fully known, was and still is the emblem of a several royal families, including the present-day Wodeyars of Mysore.

A duel, leaf from a set depicting the story of Babhruvahana, Karnataka or Andhra Pradesh. Opaque watercolour on paper, mid 19th century.

Babhruvahana firmly places his foot on a rock and aims the fatal arrow at his opponent, Prativeda, severing his head, which is lifted by a supernatural being and carried away. The headless body, slightly tilting to one side, is spiked with arrows. The palm trees in the background bend, as it were, under the exchange of arrows. Skilfully placed drops of red colour suggest blood.

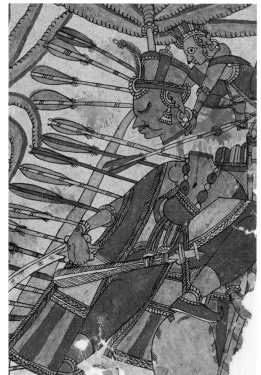

Rarely have anger and violence been expressed so dramatically as in this figure, whose body is tense in the effort of aiming his arrow at his enemy.

On the verge of falling to the ground, the body of the newly decapitated hero has an eerie grandeur. The warrior still carries a large sword firmly in his right hand and a bow in his left. A second sword hangs from his waist and his foot is still placed on a boulder, mirroring the stance of his adversary. His head, with closed eyes and a dignified expression, is being lifted by a semi-divine being.

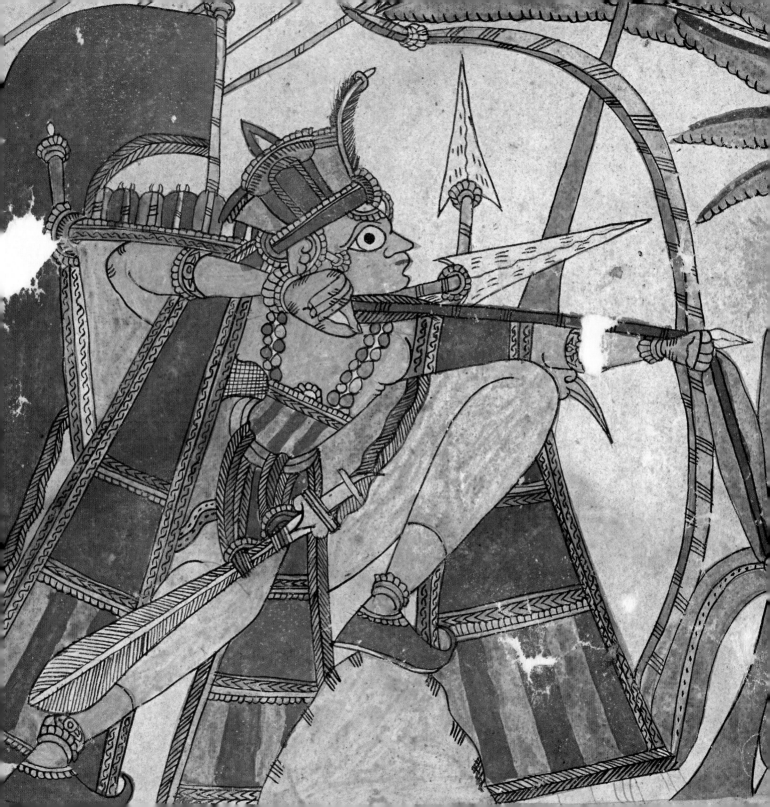

4

Devotion

Pilgrimage is one of the important duties of a Hindu: it pleases the deity, gives inner peace and increases the merit of the devotee. India is rich in holy places, *tirthas*, which are revered equally by Shaivas, Vaishnavas and Shaktas. The first and foremost of all is Varanasi (Banaras), said to encompass the holiness of all Indian *tirthas*. Interestingly, there is no religious distinction: Hindus will offer their homage also to non-Hindu holy places, such as the Basilica of Our Lady of Health at Velankanni, in Tamil Nadu, or to the tombs of Muslim saints, such as that of Sikander Shah at Tirupparankunram, near Madurai. *Tirthas* are often set in dramatic surroundings – caves, lakes, forests and mountains – and are connected with a specific deity or a mythical event. Every *tirtha* is celebrated in the local lore; texts locally compiled, and now readily available in many Indian languages as well as, occasionally, in English, highlight the connection of the place with deities, heroes and saints, contributing to its fame and its wide appeal. Pilgrimages are generally undertaken between November and early February.

To say that in India every day is a holiday is no exaggeration. Occasions such as the changing of seasons, events in the life of a deity, phases of the moon, conjunctions of the planets, rising and setting of constellations, solstices and equinoxes, all call for a special celebration. Many festivals centre on local temples, as each has its particular calendar of events, the most important being the anniversary of its foundation and the chariot festival, the *rathotsava*, during which the lavishly dressed and bejewelled metal images of the temple's main deity, its consort and attendant deities are placed on chariots and dragged by the devotees along a special ceremonial route either around the temple or through the town. This is the climax of a festival lasting between nine and eleven days, during which the main deity of the temple is paraded each day in a different costume and matching ornaments on a different *vahana*, conveyance, connected to its life history. The chariot, an intricate wooden structure whose lower portion rests on a number of solid wheels, is covered with elaborately carved timber panels. Each year, a new superstructure consisting of ready-made posts is fixed on the platform of the chariot and covered by a steep pyramid of bamboo rafters held together by ropes. This superstructure is then covered with brightly coloured appliqué textiles and on its top is affixed a *kumbha*, or auspicious pot, imitating a temple's finial. When the festive images have been ceremonially installed in the pavilion, the chariot is ready. Huge ropes some 50 metres long are fixed to

the metal rings on its front, and it is pulled by hundreds of devotees.

Among the numerous festivals of the Hindu calendar, Navaratri, Divali and Holi are frequently depicted. Navaratri, lasting nine nights, is a major festival connected to the autumnal equinox and is celebrated during the month of Ashvina (September–October). It centres on two major mythological events: the goddess Durga's victory over Mahishasura and Rama's over Ravana. In eastern and southern India, Durga is the focus of the festivities. In those parts of India in which the emphasis is on Rama's victory, the tenth day is called *Vijaya-dashami* or Dasara, 'the tenth of victory', because it is believed that Rama worshipped the goddess Durga for nine days before attacking Ravana on the tenth. For this reason the festival is a royal as well as a military occasion. In the past, it was customary for military campaigns to commence at this time.

Divali, also called Dipavali, 'row of lamps', occurs during the month of Karttika (October–November), lasts for four or five days and is celebrated with great pomp all over India. On the fourth day, the real Divali, the lamps, which are generally small earthen bowls filled with oil, are lit and placed in rows inside houses, on terraces and on garden walls; fireworks are also set off, to mark the return of Rama to Ayodhya after his exile, and his coronation.

The festival of Holi commences ten days before the full moon of Phalguna (February–March), but the climax of the celebrations are on the last three days, culminating on the day of the full moon. Very popular in northern India, this was once a fertility festival and retains some of its riotous characteristics: bonfires intended to burn evil, loud playing, obscene language and gestures. Its most characteristic feature consists of squirting coloured water or throwing coloured powder at people.

Private devotion assumes many forms, and every family regularly worships its own patron deity. With today's fragmentation of the extended family, this often entails long journeys to the ancestral home where the annual celebrations are held. Devotees can, however, choose a personal god, *ishtadevata*, to whom they owe a special allegiance for assistance in their own life and spiritual development.

The seven enclosures of the Shri Ranganatha temple, Thanjavur area. Page from an album executed on European paper watermarked 1820. Opaque watercolour on paper, *c.* 1830.
Srirangam, site of the Shri Ranganatha temple, one of the three most sacred Vaishnava temples in India, is situated on an island in the river Kaveri, a short distance from Tiruchirappalli. The river is shown on the sides of the painting, skirting this imposing temple town, which is laid out in seven concentric enclosures entered by towered gateways. The smaller shrines, dedicated to various deities and Vaishnava saints, are painstakingly rendered with details such as the chariot and the elephant.

The main sanctuary, enshrining an image of the reclining Shri Ranganatha, is prominently shown. Although in reality the sanctuary is much smaller than many of the other structures, its size here is determined by its religious importance rather than its actual dimensions.

LEFT: The two-armed deity reclines on the coils of the five-hooded serpent Shesha. His right arm is bent and rests beneath his head, while his left lies at his side. On a cloud floating above the deity is his devotee Vibhishana.

ABOVE: The Chandrapushkarani is an oval tank near which is a banyan tree worshipped by those wishing for offspring. All around the tank are shrines dedicated to various deities, Vaishnava saints and holy personalities.

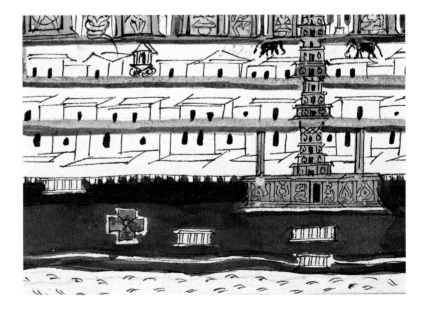

RIGHT: The temple town is entered by its south *gopura*. The visitor has to walk through six enclosures before reaching the main shrine in the seventh. In the third enclosure are 'parked' the temple chariot and two elephants. From this point on, the density of shrines, small temples and chapels increases dramatically and climaxes in the main shrine. The south *gopura*, shown here unfinished, was not completed until 1987.

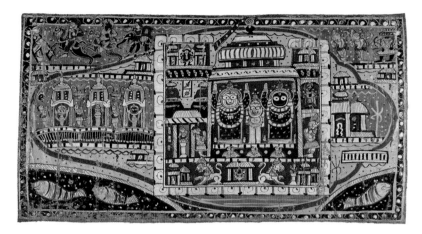

Plan of the Jagannatha temple at Puri, Orissa.
Pigments on cloth, late 19th century.

One of the most famous pilgrimage places of India is Puri, on the shore of the Bay of Bengal. The town is conceived as being in the form of Vishnu's conch. At its centre is the temple dedicated to Jagannatha, a form of Vishnu. In its sanctuary, surmounted by a schematically rendered roof with a finial in the shape of Vishnu's discus, is enshrined the Puri triad (from right to left): Jagannatha, his sister Subhadra and his brother Balabhadra. To the left, outside the main shrine, the chariots of the three deities are parked. In the top left corner is the Kanchi-Kaveri story, in the top right Rama and Lakshmana fight against Ravana. Three spirited fish swimming in the foreground suggest the Bay of Bengal.

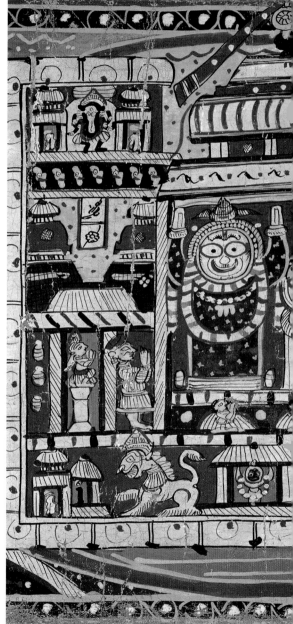

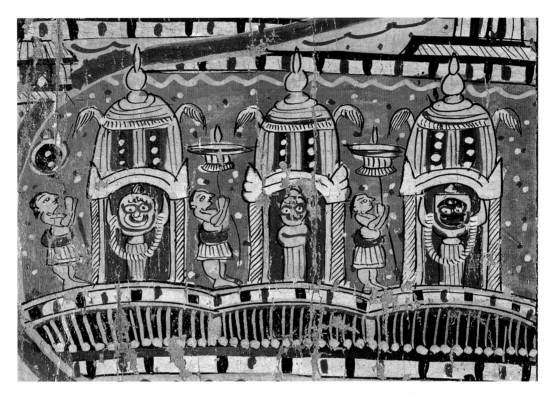

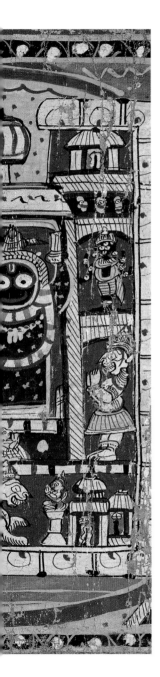

LEFT: A number of legends account for the striking appearance of the three wooden images enshrined in the temple. All have large heads resting on stumps. Their disproportionately short arms issue, as it were, from their ears. Jagannatha, with his typical round eyes, is black; Subhadra and Balabhadra, golden- and white-complexioned respectively, have almond-shaped eyes. Surrounding the temple are subsidiary buildings, minor shrines – such as the one dedicated to Ganesha (upper left) – and the eastern gate guarded by two lions.

ABOVE: Every year the chariot festival is celebrated in June–July. The three images are transported out of the town for an eight-day vacation on three huge chariots. The tallest and bulkiest of the three is that of Jagannatha, about 15 metres high and 11 metres long, with 16 wheels hauled by 4,200 professional pullers. The English word 'juggernaut' is derived from this cumbersome conveyance.

**Plan of the Shri Minakshi–Sundareshvara
temple at Madurai, Thanjavur.
Page from an album on European paper
watermarked 1820. Opaque watercolour
on paper, *c*. 1830.**

Madurai is a vibrant town in the heart of Tamil
Nadu, famous for its temple dedicated to its
tutelary goddess, Minakshi. The great temple at
the centre of the town is schematically
represented on the page. The complex is
defined by the towers on four sides and by
spacious pillared halls in which there are a
number of smaller shrines. To the left is the
temple of the goddess Minakshi, in its own
enclosure. It is entered through the majestic hall
dedicated to the eight goddesses, behind which
is the Golden Lily tank. The goddess enshrined
in her sanctuary is prominently shown. To the
right is the temple of her consort,
Sundareshvara, the 'beautiful Bridegroom', a
form of Shiva. Opposite it are the flagstaff and
the crouching image of the bull, Nandi. Along
the pillared corridors are the shrines dedicated
to various deities.

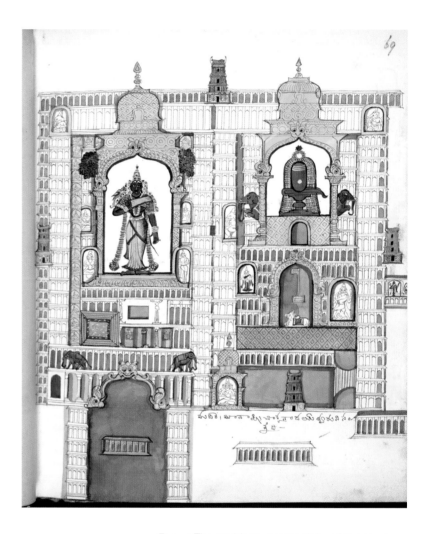

RIGHT: The goddess, patron deity of the town,
stands with a parrot perched on the flower
sceptre in her right hand, her left hanging
loosely at her side. Her complexion is green – an
auspicious colour – and she wears a crown,
shoulder ornaments, necklaces of different
designs, armlets, bracelets and anklets. On her
shoulders is draped a garland of flowers.

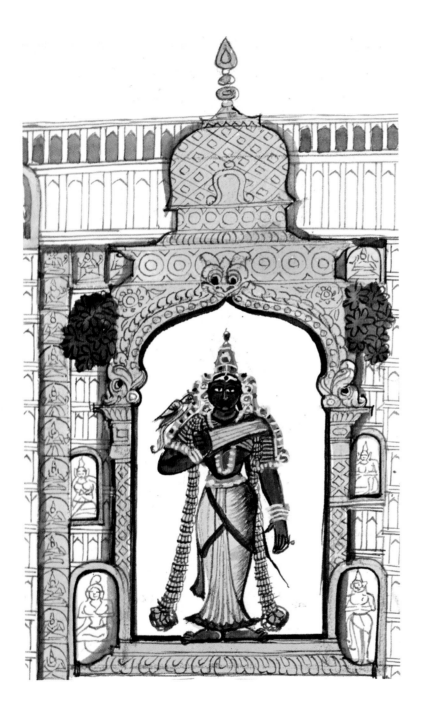

ABOVE: Easily recognizable from the two elephant figures emerging from its walls, the sanctuary enshrines a *linga* covered with flower garlands and adorned with sandal paste marks set on a spouted pedestal.

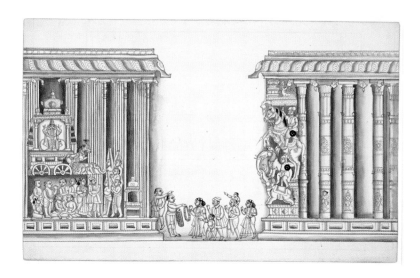

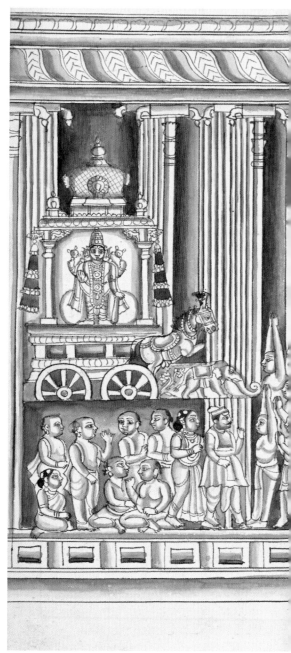

Worshippers in a pillared hall at Srirangam, Thanjavur or Tiruchirappalli. Pen and ink drawing on paper, *c.* **1820.**

This scene is set in the great temple dedicated to Shri Ranganatha, an aspect of Vishnu, at Srirangam. In the course of the *Vaikuntha Ekadasi* festival (December–January), the metal image of the deity is carried to this pillared hall, where the devotees have an opportunity to pay homage to it. A Brahmin spots an extended family with a number of children approaching and, with a gesture, secures their attention. At the entrance of the hall another Brahmin, with a flower basket hanging from his wrist, sells a garland of flowers to a woman holding a child by the hand. Another child, seated on the shoulders of his father, points excitedly to the pillared hall, where a number of devotees with hands lifted high above their heads worship the image. To the left, a group of standing men and a woman seated opposite a Brahmin take part in some special *puja*.

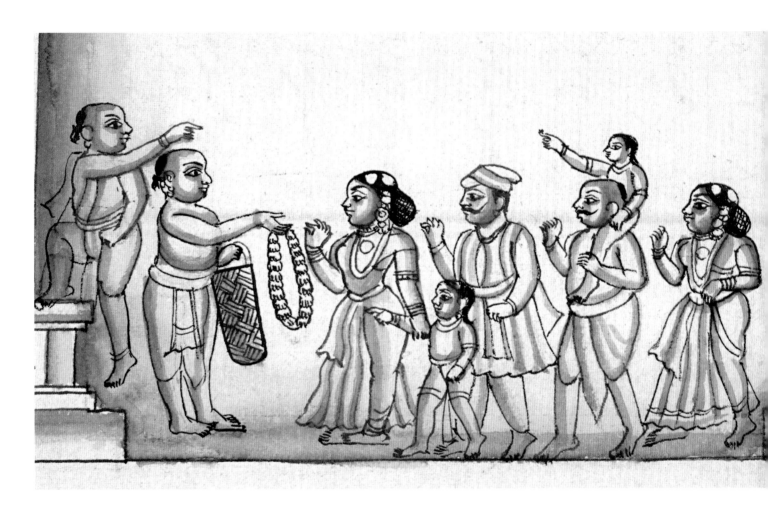

ABOVE: This superb vignette conveys with an extraordinary immediacy the excitement of a family visiting the temple on this auspicious occasion. The various characters, from the Brahmin inviting the group to perform *puja* under his guidance to the child perched on his father's shoulders, are rendered with remarkable liveliness.

LEFT: Below the horse-drawn chariot enclosing the image of the deity is a crowd of devotees. They are depicted worshipping the image with the devotional fervour inspired by this festival.

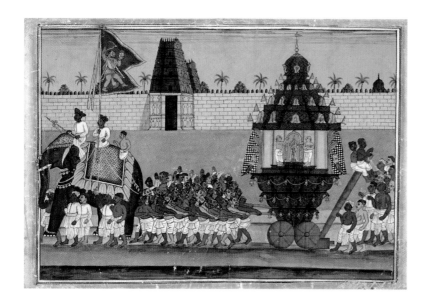

Ceremonial chariot, Thanjavur or Tiruchirappalli.
Opaque watercolour on paper, late 18th or early 19th century.

A richly caparisoned elephant, with decorated tusks and wearing strings of bells, leads the procession. On it, amongst others, is a man carrying a pennant with the image of Hanuman. Crowds of devotees surround the chariot's cumbersome structure, which houses a metal image of the god Rama. Flanking it are two Brahmins: one carries a tray with lamps in one hand and a bell in the other, the other throws petals on the holy image while muttering prayers. Immediately behind the elephant, part of the crowd pulls the chariot's thick ropes, while others at the back assist in setting the chariot in motion with the help of the lever. Some, in the background, lift up their hands in a frenzy of devotion. The backdrop shows the peripheral wall of a temple, which could be the famous one dedicated to Shri Ranganatha at Srirangam.

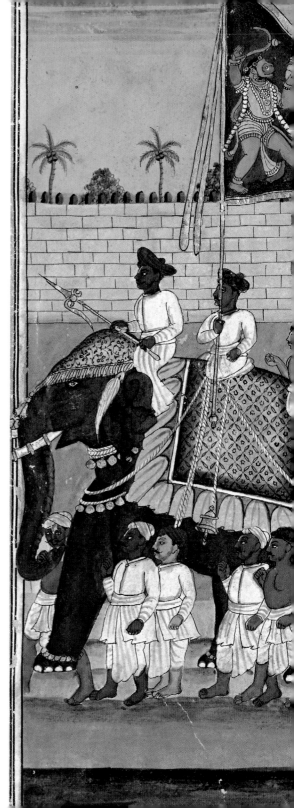

LEFT: Three men sit on the elephant: its driver, with the elephant goad in his hand; a second man carrying Rama's insignia – a flag showing Hanuman bearing the mountain with the healing herbs; and a third, who is perched precariously on the elephant's rump.

RIGHT: Great attention has been lavished on the details of the chariot's structure, such as the tiered roof adorned with fluttering flags, the plantain stems and fronds tied to the left and the right of the miniature shrine, and the chequered cloths decorating its sides. The heavy chassis of the vehicle, resting on solid wooden wheels, is embellished by three rows of carvings and chains from which hang small bells. A group of devotees, encouraged by the bystanders' shouts, perch on the lever, while others pull it down with the help of a rope. This initial thrust will set the chariot in motion. In the middle of all this bustle, the Brahmins flanking the image perform the *puja* unperturbed.

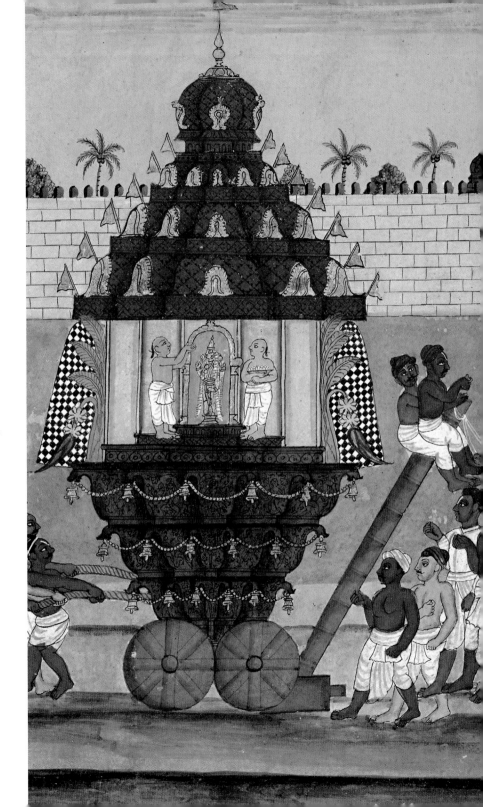

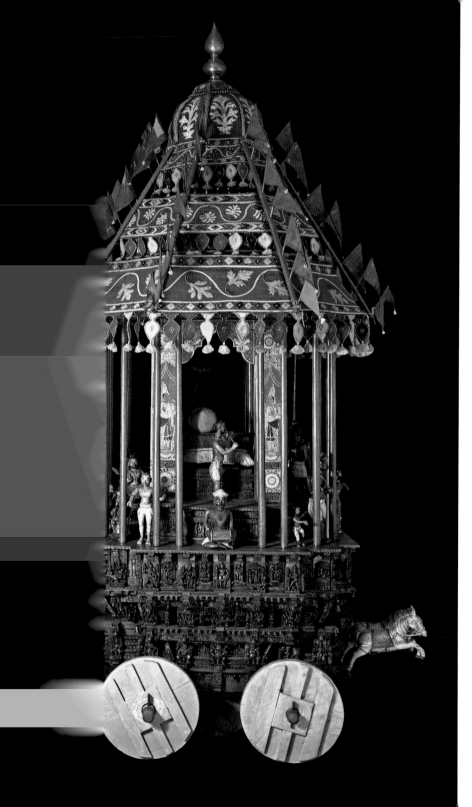

Chariot, Tamil Nadu. Wood and cloth, late 18th century.

This large model of a chariot, about 2 metres high, is probably among the earliest objects acquired by the British Museum. Built in Tamil Nadu by skilled craftsmen, it is an exact replica of one of the processional chariots (*ter*, in Tamil) which are dragged by hundreds of professional chariot pullers – only selected families have access to this honour – by means of huge ropes. The bulky conveyance consists of a wooden chassis, on which are fixed solid wooden wheels, and a temporary superstructure which is built anew each year. On the chassis are three rows of carvings, depicting incidents from Hindu mythology, beautiful maidens and martial scenes. The tiered roof, covered by a cloth with appliqué work, is adorned with fluttering flags. At the front of the *ter* are four horses driven by a charioteer. Inside the chariot, all around the dais on which the sacred images should be placed, are numerous wooden figures depicting priests, musicians and dancers. On festive occasions the metal image, bejewelled and decorated, would be placed on the small throne inside the chariot.

RIGHT: Two diminutive horses driven by an elegantly dressed charioteer pull the chariot. In reality, devotees pull the chariot. However, pith or papier-mâché horses are an indispensable accessory in the chariot's decoration. Behind the charioteer the intricate carving can be seen.

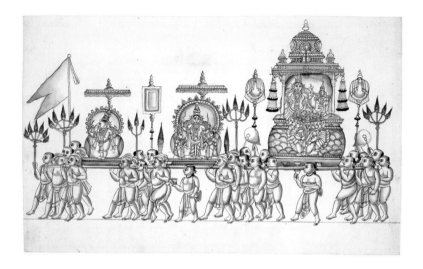

The family of Shiva carried in procession, Thanjavur or Tiruchirappalli.
Pen and ink drawing on paper, *c*. 1820.

Preceded by a pennantbearer and a torchbearer, the first palanquin in the
procession carries a metal image of Ganesha standing propped up against
a bolster, enclosed in a florid frame surmounted by a parasol. On the
second palanquin, similar to that of Ganesha, is his brother Subrahmanya,
flanked by his two consorts. The third palanquin bears the images of Shiva
and Parvati seated on Mount Kailasa, a tableau illustrating a famous
mythological incident culminating in the imprisonment of the 10-headed
and 20-armed Ravana beneath the mountain. The divine pair sit in an
elaborate pavilion on top, while the imprisoned Ravana, trapped beneath it,
sings the praises of Shiva. Groups of Brahmins with torches, fly-whisks,
pennants and mirrors accompany the three palanquins.

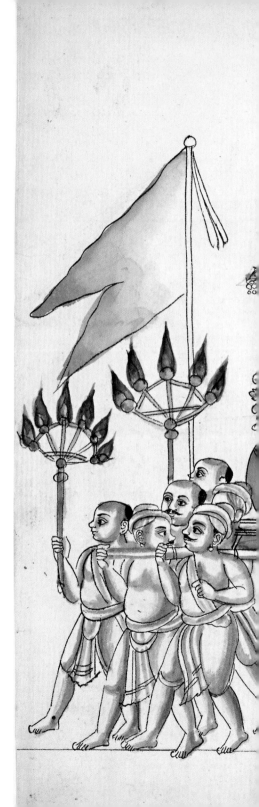

LEFT: A group of six men, including two torchbearers, a pennant bearer and three others carrying the poles of Ganesha's palanquin, walk briskly ahead. Their keen expressions and lively movement have been beautifully captured by the artist.

RIGHT: Supported by a number of Brahmins and accompanied by fly-whisk, pennant and torchbearers, the third palanquin carries Shiva and Parvati on Mount Kailasa. The mountain is depicted as a mass of round boulders surrounding Ravana's mighty figure. He has nine heads – he cut his tenth head off, to fashion the *vina* with which he accompanies his praises of Shiva – and 20 arms. Shiva and Parvati, resting their shoulders against a bolster, sit in an elaborate *mandapa*, whose roof is supported by elegantly wrought pillars decorated with pearl tassels. Near the palanquin is a Brahmin with a completely shaven head but for a tuft of hair at the back, holding a goblet in one hand and a brass tray in the other.

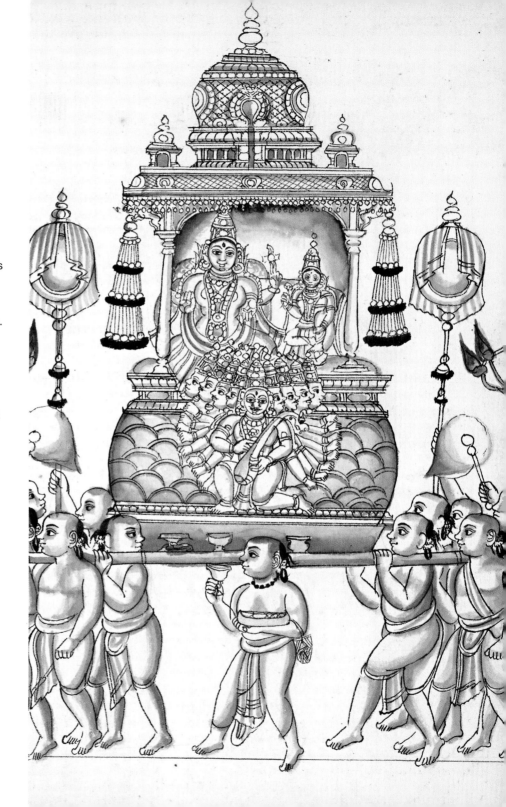

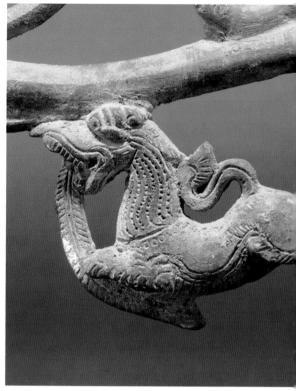

Lamp in the form of a tree, Tamil Nadu. Bronze, *c.* 18th century.
Attractively shaped like a tree, this 27-armed lamp was probably used in processions. Its lowermost arms are supported by two leaping *yalis*, while Hanuman kneels with outstretched arms at the foot of the central one. The image of Hanuman suggests that this lamp was used in a temple dedicated to Rama.

With feline elegance, these fabulous creatures stretch their slender bodies in an arabesque supporting the lowermost arms of the lamp.

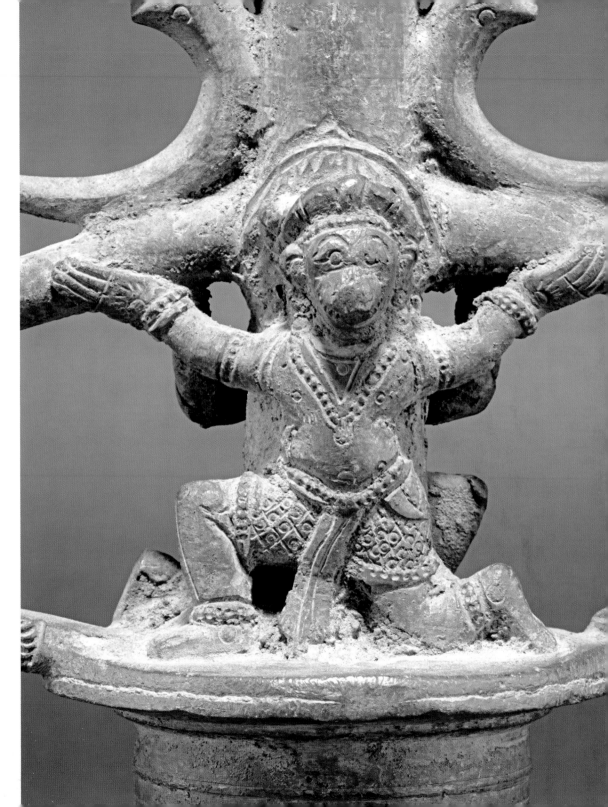

Hanuman, famous for his superhuman strength, kneels at the central base of this 27-armed lamp, supporting it on his outstretched arms.

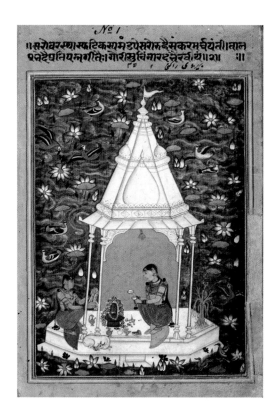

Bhairavi *ragini*, **Manley album, Amber(?).**
Opaque watercolour on paper, *c.* **1610.**

A devotional, meditative mood pervades this
painting, which illustrates *ragini* Bhairavi, an
early morning melody. The poem on the top of
the page describes a beautiful young woman as
she performs *puja* in honour of Shiva in a
pavilion in the middle of a lake. As she kneels
praying before the beautifully decorated image,
her attendant lifts a garland from the basket,
waiting for the appropriate moment to give it to
her. On the steps leading from the water to the
pavilion is a diminutive crouching Nandi, and a
banyan tree grows to the right of the shrine.

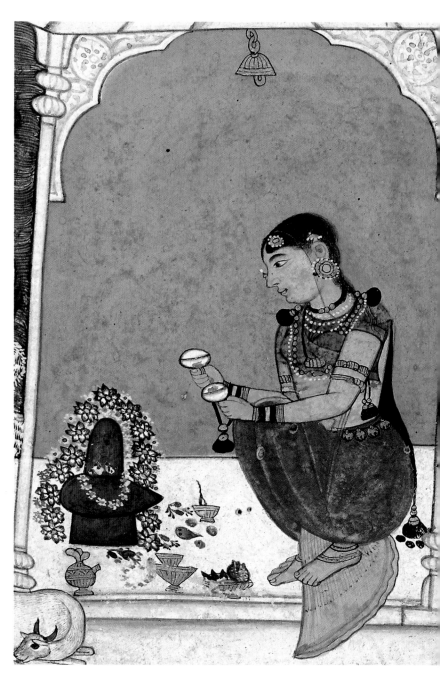

LEFT: A young lady worships the Shiva *linga* performing *puja*. She is clad in a vibrant red skirt and blue blouse, a gossamer yellow veil covering her head and body. Beautiful ornaments adorn her head, neck and arms. Her choker and armlets are fastened by black strings ending in decorative tassels and another larger tassel hangs at the end of her long plait. The pair of cymbals in her hands punctuates her chanting. The *linga*, decorated with garlands of lotuses and white flowers, is surrounded by the implements used in daily worship: two spouted pitchers, various bowls, an oil lamp and a tray with leaves, fruit and flower petals.

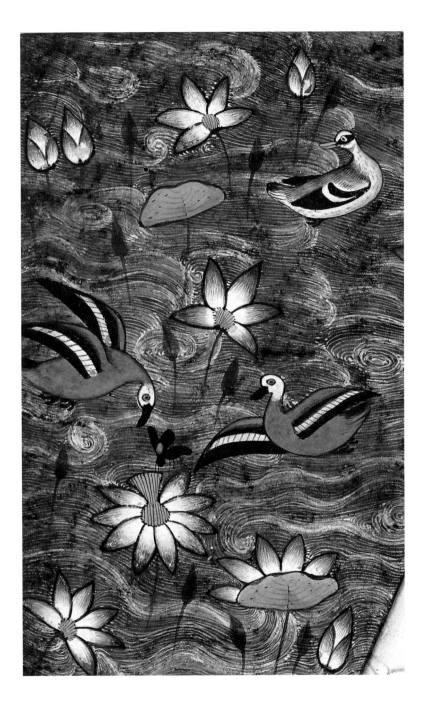

RIGHT: Wild geese swim and fly among the pink and blue lotus flowers – some in bud, some just open, some in full bloom – in this enchanting expanse of water. Whirlpools and waves animate the blue water background in which the birds and lotuses are decoratively placed.

**Elephants worshipping a *stupa*,
Amaravati, Andhra Pradesh.
Marble, late 2nd–early 3rd century.**

A popular theme in all Indian religions is the animal devotee: here the *stupa*, a symbol of the Buddha, is honoured by two elegantly modelled elephants carrying floral garlands in their trunks. This block was probably the end part of the railing coping, terminating at one of the gates of the Amaravati *stupa*. The lower part of the building is adorned with two pillars carved in low relief below a plain railing. Around the dome of the *stupa* are coiled two four-headed *nagas*, above whose heads, on both sides of the structure, are groups of umbrellas emerging from its summit. The panel is defined on both sides by a tree whose leaves and fruit are delicately carved. The inscription at the base of the block bears the names of the donors.

BELOW: A symbol of fertility, strength, wisdom and royalty, the elephant is one of the most prominent animals in Buddhist, Jain and Hindu lore. The Buddha is said to have descended into the womb of his mother in the shape of a small, six-tusked elephant and, in his former lives, often took the shape of an elephant. This sensitively modelled animal, with its flapping ears and massive body, appears to be kneeling in front of the *stupa*.

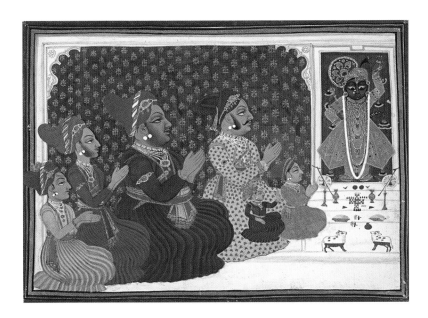

Maharaja Ragho Das and his sons, Raghugarh(?).
Opaque watercolour on paper, *c.* 1790.
Rulers were often portrayed while at worship. In this vibrant painting
Maharaja Ragho Das and his sons, two adults and three younger ones, are
seen engaged in the worship of Shri Nathji, a form of Krishna particularly
popular in parts of Rajasthan. The raja sits opposite the holy image, with
his hands in *anjali mudra*.

The holy image is enshrined in what appears to be a domestic shrine.
On the steps in front of the image are various objects such as vessels,
lamps, a *pachisi* game board and dice, flowers and two small cows.
Flanking the image are two bolsters, betel leaves and two cowherd sticks.

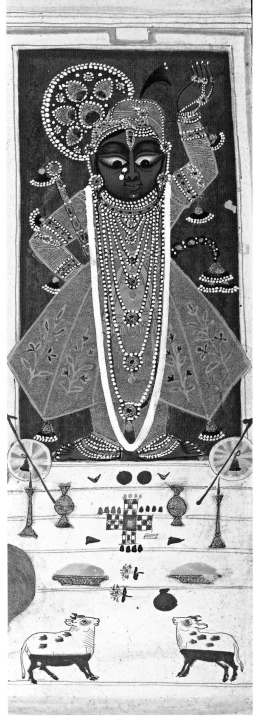

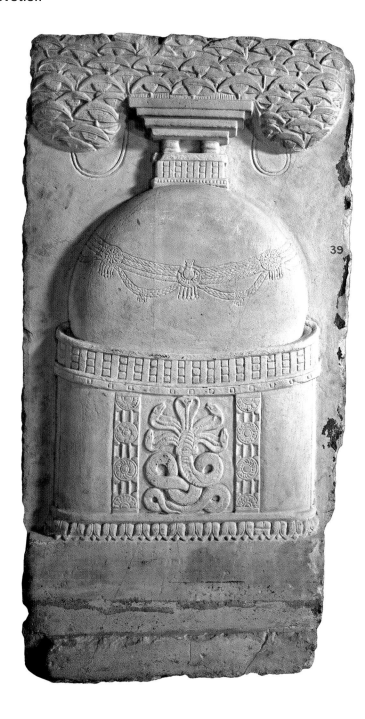

39

**A *stupa*, Amaravati, Andhra Pradesh.
Marble, 2nd century AD.**

This slab depicts an unadorned *stupa* on a lotus petal base. The details of the railing are dispensed with and the gate is flanked by two pillars decorated with four lotus roundels. In the opening is a magnificent, sinuously curved five-headed *naga*. Surrounding the dome, which is decorated with long garlands interrupted by large lotus medallions, the central one bearing the image of a seated bird, is a low railing. From the stepped *harmika*, the railed portion at the summit of the *stupa*, erupts a profusion of honorific umbrellas. The parasol or umbrella is one of the insignias of royalty and power, as well as being an attribute of various deities. In a metaphorical sense it represents the spiritual power of a deity, which is indicated here by the fact that the umbrellas emanate from the *stupa*.

RIGHT: The *nagas*, snakes (especially cobras), are a category of semi-divine beings reputed to be the guardians of precious minerals, gems and other riches stored beneath the earth's surface. Renowned for their wisdom, skill and beauty as well as their quick temper, they play a major role in folklore and many Buddhist, Jaina and Hindu legends. Particularly famous is the great seven-headed *naga* king, Muchilinda, who saved the meditating Buddha from the flood by lifting him above the water level on his coils, sheltering the Buddha from the pelting rain with his seven hoods.

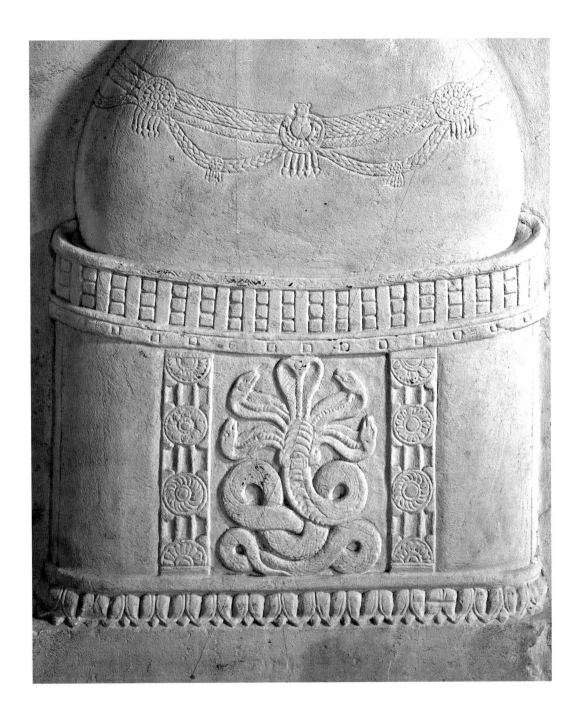

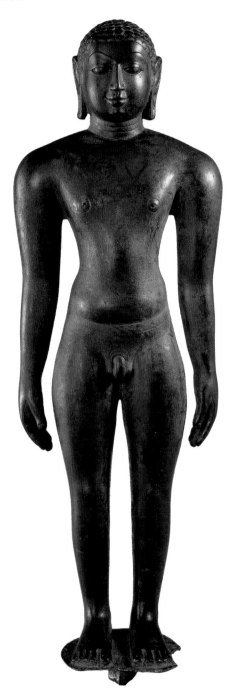

Jain *tirthankara*, Karnataka. Bronze, 10th–11th century.

In accordance with Jain iconography, this *tirthankara*, 'ford-maker' and prophet-saviour, is shown naked, standing upright with long arms, his narrow 'lion-like' waist emphasized by the breadth of his shoulders 'like those of a bull'. The taut and elegantly shaped torso is filled with energy. Rarely, as here, has the human body been represented combining the spiritual with the sensual. The most striking feature of this bronze is the timeless calm it radiates. Its very simplicity, the absence of ornament and other details, expresses sublime detachment from all earthly concerns and the achievement of mental harmony. The sensitive and restrained modelling suggests the plasticity of the body.

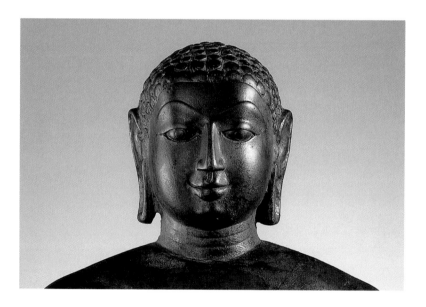

The closely cropped hair, elongated ear lobes and three auspicious folds on the neck are also typical features.

Jambudvipa, Rajasthan, possibly Mewar.
Painting on cloth, *c*. 17th century.

According to Jain thought, the universe is divided into three worlds, but the most important is the central world, that of the mortals. This is where liberation from the chain of rebirth is possible and where the Jinas are born. This painting depicts the central continent of the middle world, the Jambudvipa, island of the *jambu* tree. Various rivers criss-cross the island. At its centre is the sacred mountain Meru, the axis of the universe, and it is surrounded by the ocean, filled with aquatic life and auspicious pots. Fabulous animals with elephant heads and lion bodies appear around the edges of the sea.

5

Courtly and village life

OPPOSITE:
Detail from the month of Karttika (October–November), a page from a dispersed *barahmasa* series, Bundi. Opaque watercolour on paper, late 17th century.

In traditional India, the ruler is styled *chakravartin*, 'universal ruler', a term denoting both spiritual and temporal kingship. The power of a *chakravartin* extends over the whole earth. He possesses chariots, jewels, wealth, horses and elephants, and he is considered the ideal man, with all auspicious signs on his body and possessing every spiritual and moral quality. Through all the political and social changes over the centuries, the concept of the ruler as the ideal man, the epitome of strength, valour, virility and spiritual accomplishments, lingered on. This is shown in the highly idealized 'portraits' found, for instance, in Rajput and Pahari painting.

Paintings from Muslim and Hindu courts are rich in depictions of kings and noblemen engaged in activities ranging from giving audience to listening to music, from hunting to visiting their wives in the *zenana*, the women's apartments, and from routing the enemy to worshipping a deity. At the Hindu courts, especially, it was customary to portray the raja engaged in worship, either alone or with his sons and relatives. It was a way of showing the strong links which tied the ruling family to the tutelary deity of the state, thus legitimizing their power.

Royal portraits stress the ceremonial aspects of a ruler's life and are an idealized vision of law and order. Very few artists – Nainsukh, friend and court painter of Raja Balawant Singh of Jasrota, was a rare exception – had the opportunity to study their rulers at close quarters, when the trappings of power were discarded and the true personality of their subject came to the fore. Hunting scenes provided the artist with dramatic landscapes of rugged hills and dense forests through which the ruler and his followers could ride, shooting deer, gazelles, bulls and tigers, and fighting boars on foot. In some cases a particular incident is recorded, as, for instance, when one of the courtiers, pursued by a huge boar, seeks refuge atop a tree. Some hunting scenes, however, are an extension of the formal *darbar* scenes: the ruler sits in a wild landscape under a superbly embroidered awning, surrounded by his standing courtiers, and the bag is ceremonially spread in front of him. Attendants and

menials in charge of spotting and rounding up the animals are shown at a considerable distance.

A number of paintings focus on the royal women in the *zenana*. Although it was out of bounds for anyone but the ruler and the servants, this did not prevent the courtly ladies from being portrayed with their consort or engaged in activities such as listening to music, conversing or looking after children. The paintings emphasize feminine beauty and elegance: finely drawn faces with carefully pencilled eyebrows and beautifully dressed hair, while the painstakingly rendered details of dress and jewellery mirror the sophisticated courtly ambiance. However, beneath all the refinement were bitter rivalries. A woman's position was insecure and she had to please her husband if she was not to lose her status, indeed her life.

In Mughal miniatures, possibly the most refined expression of courtly painting, there was little space for subjects such as ideal beauty and idealized lovers, themes present in Indian art from earliest times. However, romantic subjects were extremely popular at the Rajput courts of the plains and the hills, where the divine lovers Radha and Krishna, celebrated in poetry, music and painting, were the model for human couples. Often Rajput rulers were portrayed in the guise of Krishna,

along with their beloved, in splendid gardens or palatial surroundings, as seen in the illustrations to the *barahmasa*, the 12 months of the year, or in depictions inspired by love poetry. *Ragamalas*, paintings depicting the various *ragas* and *raginis*, the male and female melodies of Indian music, were yet another great creation of courtly painting, combining three of the most inspiring themes of Indian poetry: the story of Krishna, the *barahmasa*, and the *Rasikapriya*, a work detailing the behaviour of lovers.

Outside the walls of the palaces, painters had the opportunity to study everyday life, and their observations were incorporated into their work. Occasionally, actual market people such as toy, cloth and bangle sellers are shown. However, it is at the close of the 18th century that, in the wake of the interest shown by the newly established British rulers, painters churned out endless sets depicting trades and occupations as well as castes. These paintings, simply laid out, depict a man and his wife in their traditional attire, holding the tools of their trade. The couples often seem marooned on a plain foreground, with perhaps just a few trees in the background. In these sets, religious mendicants of all descriptions, tradesmen, servants, yogis and fakirs, are all rendered with documentary precision.

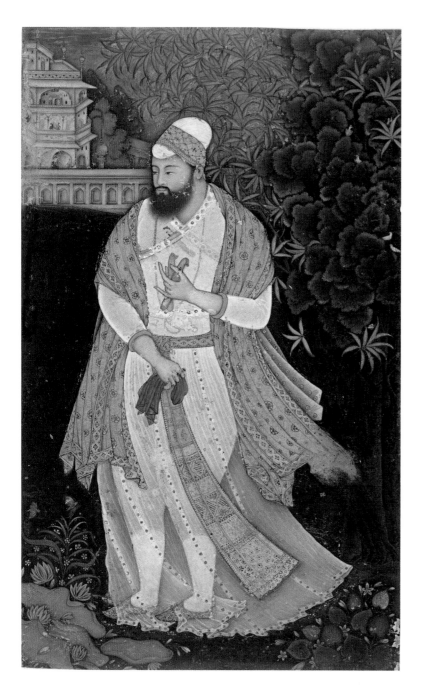

Portrait of Ibrahim Adil Shah II of Bijapur, Bijapur. Opaque watercolour on paper, c. 1615.

This intriguing portrait, with its mysterious background, is typical of the Bijapur school of painting which flourished under the reign of Sultan Ibrahim Adil Shah II (1580–1626). He was the product of a hybrid culture, with an aesthete's admiration for both Hindu and Muslim cultures. Under his rule, the art of painting was elevated to an unequalled level of refinement.

The ruler stands in a magnificent garden, holding in his right hand a kerchief, an old Islamic symbol of kingship, and in his left the castanets used by musicians to beat time – a testimony to his great love of music, in which he excelled. His full beard, conical turban and chain of *rudraksha* beads reveal his identity. He is dressed in flowing robes with a gold-coloured band on his turban, gold-coloured sash and shawl. His rich clothes sway around his majestic figure as if in a breeze. A lush display of flowers enlivens the foreground. In the background is a carefully rendered palace. The poetic atmosphere conjured up by the artist has few equals in Indian painting.

Portrait of the emperor Shah Jahan, Mughal. Opaque watercolour on paper, *c.* 1650.

Under the rule of the emperor Shah Jahan (1627–58), the Mughal empire reached the zenith of its political power and cultural achievement. Often Mughal paintings were mounted on larger sheets of paper and provided with decorative frames, which were works of art in their own right. Here the frame is a collection of narcissi and irises interspersed with 'Chinese' clouds.

In this formal portrait the emperor is shown with all the appurtenances of power. On his head, surrounded by a halo as if to hint at his almost divine power, he wears a turban with a pearl-studded cross band and an elegant turban ornament. His dark moustache is set off by his grey beard, and his carefully drawn profile is highlighted by a darker line. Over his wide pantaloons he wears a diaphanous *jamah*, finely embroidered with floral motifs and tied at the waist by an equally finely embroidered sash. A two-string chain of pearls – the emperor was a great connoisseur of jewellery – hangs from his neck. A dagger with a bejewelled hilt is stuck into his waistband, and on his feet are embroidered slippers.

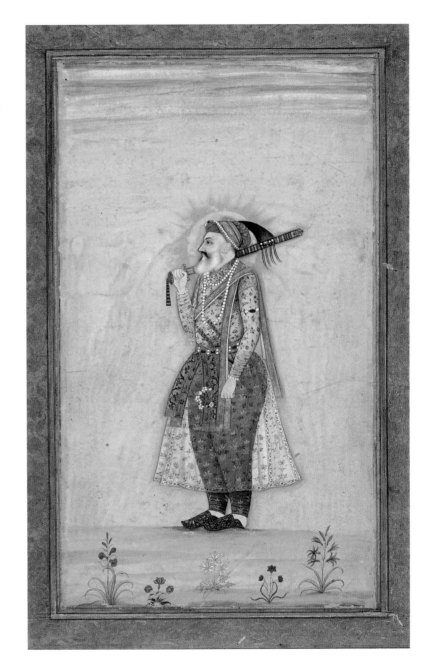

Darbar of Sultan Abdullah Qutb Shah, Golconda.
Opaque watercolour on paper, *c.* 1630.

This formal painting, in which courtiers, splendidly arrayed and bejewelled, are hierarchically arranged around the king's throne, aims to convey the image of royal magnificence. The young sultan is placed well above the centre of the painting, so not only do his pages and grooms have to look up to him, so does the viewer. Dressed in white robes with gold trimmings, the sultan wears a tightly wound red turban. He sits on a throne in a hall whose roof is supported by slender pillars. Behind him is a golden brocade bolster, and his sword rests nearby. A number of gold vessels and two footstools are placed near the throne. To the left are three attendants, two of whom are waving a long *rumal*, a kerchief. To the right are three men, probably ambassadors, and the oldest sits beside the throne. In the foreground, symmetrically placed to the left and right of a fountain and a vase of flowers, are two groups of horses with their grooms.

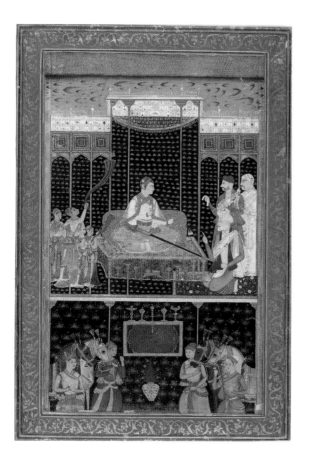

RIGHT: Two elegantly dressed youths, one an Abyssinian, and a child hold in their left hands a long *rumal* and carry various objects in their right hands. They wear vividly coloured trousers covered by flowing diaphanous white robes, tied at the waist by rich brocade sashes, and tightly wound turbans enlivened by gold cross-bands.

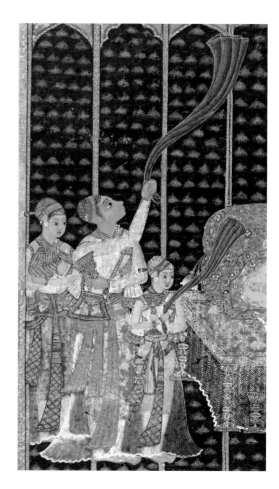

RIGHT: On each side of the fountain in the foreground is a group of two horses led by their grooms. Horses such as these, Arabian bred, were highly valued in the Deccan. The Indian climate is unsuitable for breeding good horses, so shiploads of animals were sent to India from the Arabian peninsula.

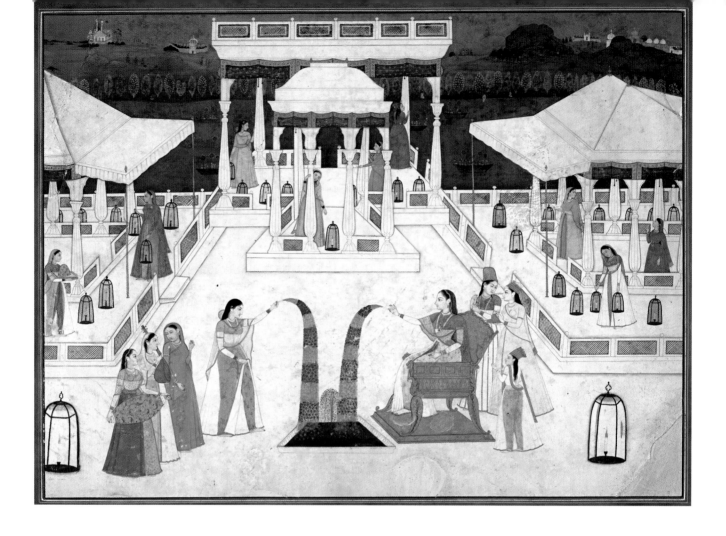

**The festival of Divali, Panjab Hills, Guler,
by Nainsukh. Opaque watercolour on paper,
c. 1730–40.**

The main theme of this unusual painting is
space defined by architecture. The artist
Nainsukh toys with many perspectives, planes
and diagonals, with arrangements of pillared
pavilions and canopied terraces. In the dark
background a river, with a number of barges,
flows quietly along a shore punctuated by trees.

At some distance to the right, nestling amid the
hills, is a town. On the left might be a walled
garden with a grand entrance and perhaps,
further to the left, yet another town. In the
foreground a noble lady sits on a chair opposite
one of her companions, lighting sparklers by a
spraying fountain. Several ladies tend to the
many candles burning beneath glass covers.
Divali means 'Festival of lights' and is celebrated
in the month of Karttika (October–November).

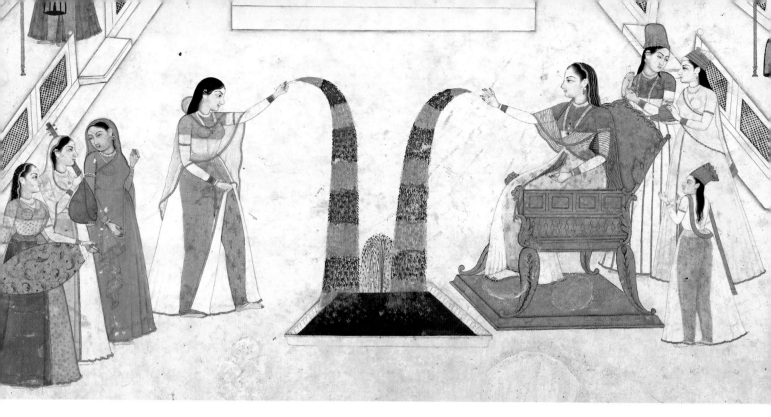

ABOVE: A strikingly beautiful young lady sits on a high chair gazing intently at the cascade of coloured sparks falling into the small cistern opposite her. Facing her is another young woman standing with a sparkler in her left hand, from which a stream of sparks falls into the same cistern. Three maids stand, softly murmuring, behind their mistress, attentive to her every wish. Opposite, three female musicians sing and play their instruments.

RIGHT: A sequence of pillared pavilions draws the eye to further pavilions and pillars. In this open setting, a number of ladies busy themselves carrying candles in glass shades or checking that everything is in order for the festival of Divali.

The month of Shravana (July–August), leaf from a dispersed *barahmasa*, Bundi. Opaque watercolour on paper, late 17th century.

This painting shows the onset of the monsoon season. The accompanying text reveals the topic of the conversation: the young woman is trying to persuade her lover not only to remain with her, but not even to step out of the house during the monsoon season. Against a backdrop of rain-laden clouds and lightning, the couple converse in a veranda on the top floor of an elegant mansion bordering on a magnificent lush landscape. An awning protects them from the rain. The young man, blue-complexioned and identified with Krishna, is dressed in courtly attire and leans his shoulders against a large bolster. His beloved, almost kneeling near him, is dressed in skirt, blouse and veil and profusely bejewelled. In her hands she holds a *pan*, a preparation of various spices and other ingredients wrapped in a betel leaf, which she has prepared for him. On the lower floor a curtain hangs over a door, and a niche in the wall contains two decorative flasks. Outside the wall of the mansion a group of ladies celebrate the festival of Tij.

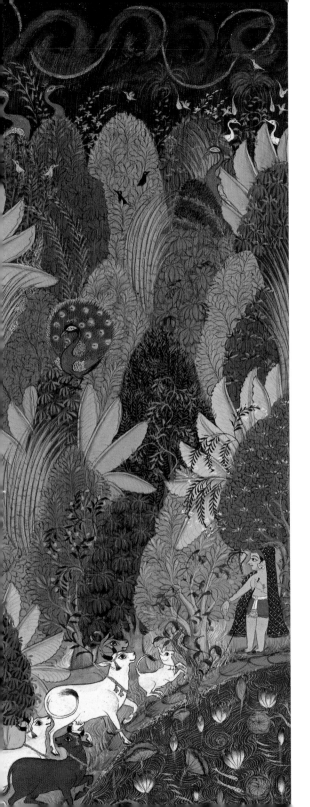

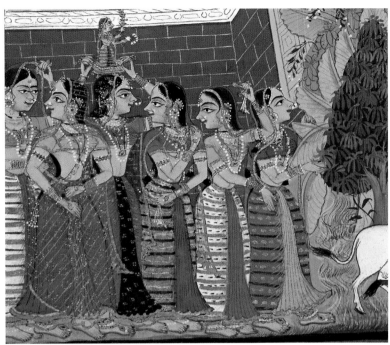

ABOVE: A group of ladies, one carrying on her head a diminutive image of the goddess Parvati, celebrate the festival of Tij, 'the third', which falls on the third day of the month of Shravana (July–August). It commemorates the end of Parvati's penance and her reunion with her husband Shiva. Anyone worshipping the goddess on this day is supposed to be granted their wish.

LEFT: Rolling black clouds pierced by a darting decorative curve of lightning unleash a violent downpour that drenches a dramatic landscape of bamboo thickets, plantains, mango trees and a variety of shrubs covered in flowers and inhabited by cranes, peacocks and other birds. Central to the composition is a magnificent peacock, proudly spreading its tail as if to greet the rainy season. A blanket-clad shepherd, his long stick in his hand, shelters under a tree near a lotus-filled pond watching the gambolling cows and calves enjoy the pelting rain.

113

Portrait of Raja Balawant Singh, Guler, Panjab Hills, by Nainsukh. Opaque watercolour on paper, *c.* 1745–50.

Balawant Singh of Jasrota is portrayed seated, leaning on his left hand and holding the pipe of the *huqqa* in his right, listening intently to the performance of five musicians. The viewer's eye wanders from the lone dignified figure of the seated raja to the group of musicians, attracted by the red dress of the singer, who is identified by the inscription as Ladbai. While the raja is depicted formally, the group of musicians, three men and two women, are rendered with great warmth and remarkable psychological insight.

ABOVE: Balawant Singh of Jasrota (*c.* 1724–63) was a famous art patron and keen connoisseur. At his court lived his life-long friend, the painter Nainsukh, one of the most talented painters of 18th-century Panjab Hills. The raja is smoking the *huqqa* while listening to music. Seated on a carpet, a bolster near him, he is fully absorbed. His erect posture, intent gaze, the black plume in his turban and the gold in its cross-band, which matches the gold in his *patka* tied at the side of the waist, his pendant and the amulet tied on his arm – all speak of understated, refined elegance.

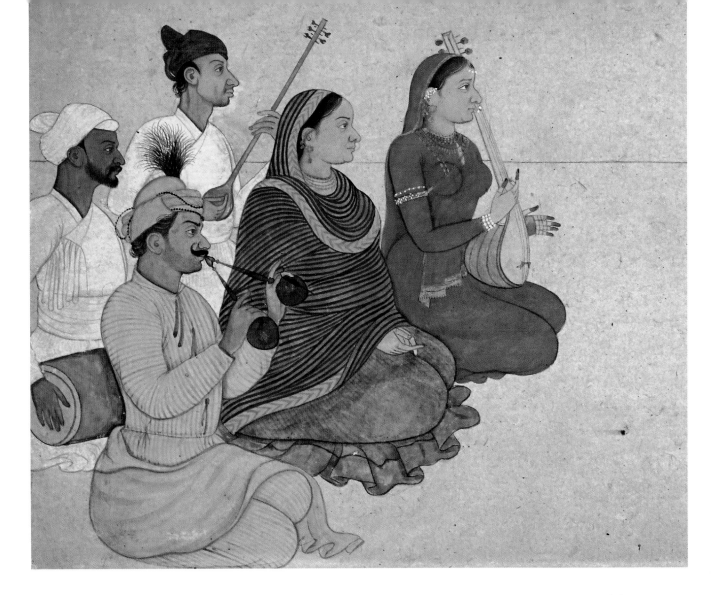

The two women and their accompanists are rendered with great attention to each individual. The singer Ladbai, dressed in brilliant red, holds the *tamboura* on her lap and plucks its strings with her carefully reddened hand while slightly extending the other in the fashion typical of singers. The older woman near her, in a striped shawl, hands resting on her lap, is not singing at the moment. The three men of the group are striking studies of individuals: the lean *ektara* player with his slightly long hair escaping from his turban, the dark-complexioned, slim, bearded *dholak* player, and the man playing what looks like a folk instrument consisting of two small gourds to which pipes are attached.

The month of Vaishakha (April–May), leaf from a dispersed *barahmasa*, Bundi. Opaque watercolour on paper, late 17th century.

Lover and beloved are engaged in an animated conversation. Nearby stand two attendants, one holding a peacock's feather swish, the other a fan. They sit on a terrace outside a spacious room with a large bed on which are two bolsters. The lover is identified with Krishna: elegantly attired and comfortably resting his shoulders on a bolster, he enjoys being looked after by his beloved. She sits opposite him and points to the diminutive figure of the god of love, Kama, concealed among the trees outside the mansion wall, who aims his flowery arrows at them. In the foreground two men, one carrying a bow and arrow, the other a sword, converse while walking briskly along a path near the shore of a lotus lake. At a short distance is a third man who, having removed his turban, fans himself with a leaf. Behind the brick wall are orchards and gardens. At the foot of a banyan tree a group of ladies worship the Shiva *linga*, while nearby peasants draw water from the lake with the help of a pair of bullocks and a gentlemen's party glides by on a pleasure boat.

The god Kama emerges as a diminutive figure from a riot of trees, flowering shrubs and lush foliage. He is dressed in courtly attire of brilliant red, the colour of passion. In his hand he carries a bow made of flowers; his lotus-tipped arrow, poised to shoot the couple on the terrace, is clearly visible.

**The emperor Muhammad Shah with ladies,
Panjab Hills, Guler, by Nainsukh. Opaque
watercolour on paper, *c.* 1735–40.**

The Mughal emperor Muhammad Shah
(r. 1719–48) sits on a spacious canopied bed on
a marble terrace brightened by soft moonlight
and lit by candles. One of his arms rests gently
on the shoulder of a young woman seated next
to him, and in the other hand he holds the stem
of the *huqqa* placed near the couch. There are
two candles in glass shades and a small
bedside table with a *pan* box and perfume flask.
Five female attendants stand at some distance
holding various objects the lovers may require.
Also standing apart are two male retainers: the
first is older and dignified, the second a dusky-
complexioned youth. In a corner are two seated
female musicians playing the *tabla* and singing
to the accompaniment of the *tamboura*. The
artist Nainsukh probably based this composition
on an original Mughal painting.

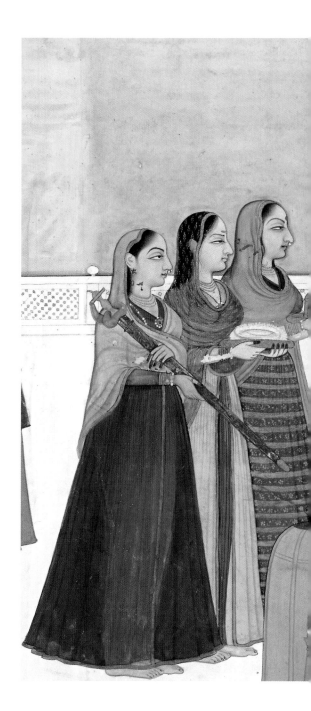

RIGHT: Five female
attendants, sporting
elegant *peshwaz*,
skirts, over *pijama*
trousers, their heads
and shoulders
covered by shawls,
stand in attendance.
They carry floral
garlands, a *rumal*,
kerchief, a *pan* box,
a tray and a sword.
In the foreground a
large candle burns
beneath a glass
covering.

RIGHT: The emperor is shown at a comparatively young age, and in accordance with traditional Mughal iconography: a halo surrounds his head and he sits against a bolster propped against one of the posts supporting the canopy of the bed. He wears a carefully tied turban with a dark cross-band, and his white *jama* is set off by a cyclamen-coloured *patka* with green border. His lady friend, a delicately built young woman, sits near him and shyly places her hand on his thigh. She is clad in a *peshwaz*, and a diaphanous shawl covers her head and shoulders.

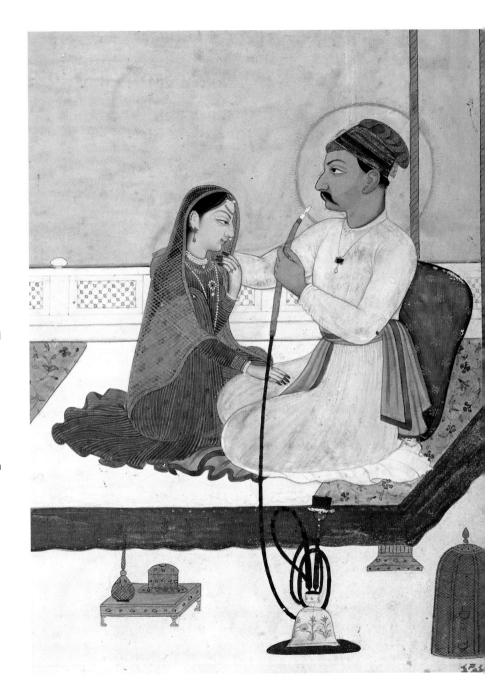

Nobleman on horse and followers, Tamil Nadu. Wood, panel from a ceremonial chariot or *ter*, 19th century.

Non-religious themes such as music and dance, amorous couples, hunting and war scenes all have their place in the iconographic programme of a temple chariot. Here a nobleman rides a beautifully decorated rearing horse. In his right hand, now damaged, he would have carried a sword; in his extended left hand he holds a buckler. A dagger is stuck in his belt and a quiver bristling with arrows hangs from the horse's straps. His three attendants are shown in the foreground, the first almost beneath the hooves of the rearing steed, the second wielding a sword (now damaged) and the third carrying a standard. The theme of the riding nobleman accompanied by his retinue has been very popular in southern Indian stone and wooden sculpture since the 17th century.

LEFT: This nobleman embodies the ideals of masculine beauty: his elegant figure is bejewelled and he is dressed in rich clothes, slippers and turban. His pronounced eyebrows and moustache give him a swaggering allure. His slightly raised head and confident expression, his raised left hand brandishing a buckler, and the manner in which he holds himself reveal proud self-assurance.

RIGHT: Following the prancing horse of the nobleman is a small standard bearer. His standard is mounted on a long pole decorated with metal rings. Behind can be seen the horse's harness and the warrior's quiver in the shape of a *makara*, from whose mouth a multitude of arrows emerge.

A boar hunt, Kotah. Opaque watercolour on paper, *c.* 1775.

In a forested landscape of rolling hills, a group of men have tracked not one
but two large boars. The one to the right is concealed among the leaves of
the forest, where only its sharp tusks and nose reveal its presence.
However, it has been spotted and shot by a group of three men armed with
swords and rifle, who are concealed behind a cow. At the centre of the
painting two men fight the second boar.

RIGHT: In the heat of the hunt, a large boar has
taken two hunters by surprise. While one
valiantly attempts to repel the animal's attack
with a long spear, the other, concealed in the
branches of a tree, wounds it with his sword.

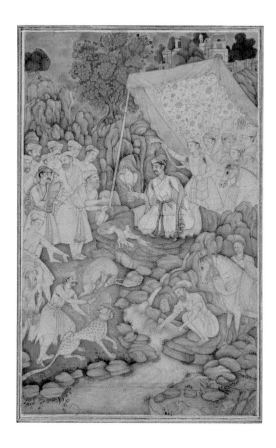

A prince receiving the bag after the hunt, Mughal.
Opaque watercolour on paper, c. 1605.

A prince, carrying a falcon perched on his right wrist, sits under a
sumptuously embroidered awning pitched in the middle of a rugged
landscape. He is accompanied by a considerable number of attendants
and courtiers: to his left are six youths and a horse, to his right is a group
of men. Opposite the noblemen are hares and fowls killed in the course of
the hunt. In the foreground, a man restrains with difficulty a blindfolded
cheetah, while opposite him another man washes his hands in a brook, and
behind him are a finely drawn horse and a groom. In the background, at a
distance behind the rocks, is a town.

ABOVE: It was customary to hunt with the help of cheetah
Captured and trained by specialized staff, they were kept
blindfolded until the hunt began, to prevent them becomi
excited and starting to run before the hunters were ready.

RIGHT: After the hunt, a group of men discuss the events of the day – a fine example of the Mughal painter's interest in the study of individuals. He seeks to capture the personality of each of the men portrayed.

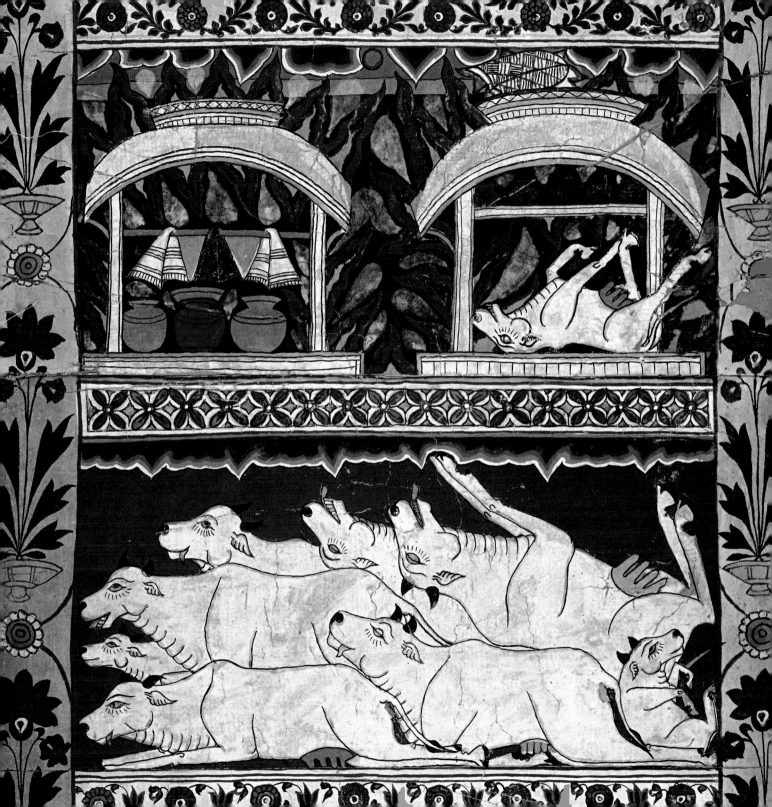

**Scenes from a 'Gazi' *pata* scroll,
Murshidabad district, West Bengal.
Opaque watercolour on paper, 19th century.**

This is a scene from a fragmentary scroll,
about 13 metres in length and containing 57
registers, which depicts a sequence of mixed
Hindu and Muslim legends, a typically Bengali
phenomenon. The scroll probably describes the
feats of at least two charismatic Muslim holy
men, *pirs*, in which both Hindu and Muslim
characters appear. Unfortunately, the details
of the story are not known. At the top, a
horrendous fire destroys two houses. A cow lies
dead in the building, probably a cowshed to the
right. Below is a group of cows in distress: at
least four of them are clearly dead, their eyes
closed, tongues protruding. Three of the dead
animals lie helpless on their backs, hooves in
the air. Both houses have the curved roof typical
of Bengali architecture. In the house on the left,
clothes hang from a pole and three pots are
carefully placed on the floor. A cow lies dead on
the floor of the building to the right. Pots and
pans are stored in the loft. Decoratively rendered
tongues of flame devour the buildings. The
vertical frame of the scroll is decorated by a
floral pattern, and the horizontal frames display
floral and geometrical motifs.

Dressed in a green sari with a red border and a yellow blouse, and heavily bejewelled, the seller seems to be one of those market ladies with an infallible nose for business, demonstrated by her apparel and confident stance.

A seller of clay images, Patna, by Siva Dayal Lal(?). Opaque watercolour on paper, c. 1870.

The complex structure of Indian society fascinated the British. During the colonial period, artists were commissioned to produce a great number of paintings depicting Indian trades and occupations. These were eventually sent to Britain, along with official documents. One of these paintings shows a potter surrounded by his wares. Nearby his wife manages a stall on which an impressive number of clay figurines are displayed. An elegantly attired client is being served.

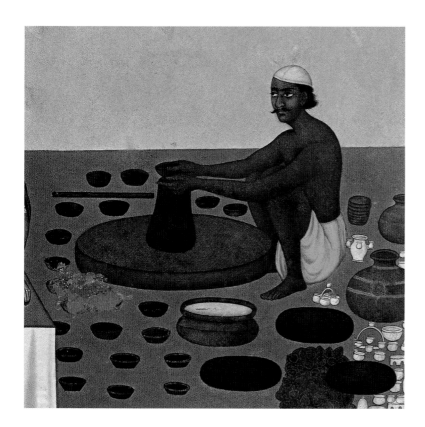

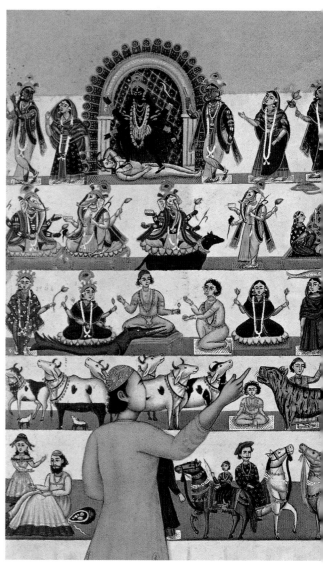

ABOVE: A magnificent study of a potter at work: he squats near his wheel while fashioning a large pot. Until the introduction of stainless steel utensils, the majority of pots, pans, cups and other household goods were made of clay. Even now, on occasions such as the Tamil festival of Pongal, celebrated in the middle of January, it is mandatory to buy new clay pots for boiling milk rice, the special sweet eaten on that day.

On display are Kali trampling on the recumbent Shiva (top row), figures of Ganesha, a water carrier, cows, tigers and horsemen, and a British lady instructing a tailor (bottom row, far left).

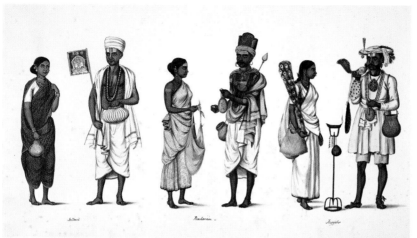

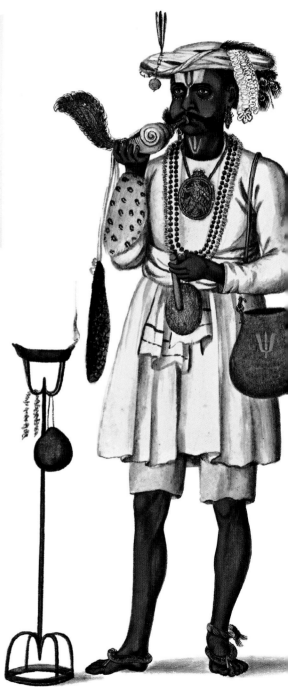

Three couples, Thanjavur. Opaque watercolour on paper, *c*. 1830.

This page originates from a set depicting trades and occupations, a theme popular in the late 18th century and throughout the 19th. The artists, by now familiar with European techniques and British tastes, produced a large number of such series, most of which are of indifferent artistic value. A few, however, such as this one, are exquisite. The aim of these series was to document Indian life, and particularly interesting are the depictions of the various religious groups. The figures – a man and wife – are generally set against a flat background. Occasionally the sky is enlivened by billowing clouds and the horizon line by trees and shrubs. Here are three couples of 'religious mendicants', each identified by an English caption. They belong respectively to the Sattani, Pandaram and Dasari communities.

Although the couple at the far right are identified by the label as 'Juggler', they are actually Dasaris, Vaishnava mendicants. The man sports a *namam* on his forehead. He wears short trousers, a flowing jacket and a turban decorated with peacock feathers and other ornaments. Hanging from his neck is a large round plaque representing Hanuman and numerous strings of *rudraksha* beads. He blows an ornate conch shell, while in his left hand is a metal gong with a wooden mallet. Hung on his right shoulder is a begging bowl. Beside him is an oil lamp on a long stand.

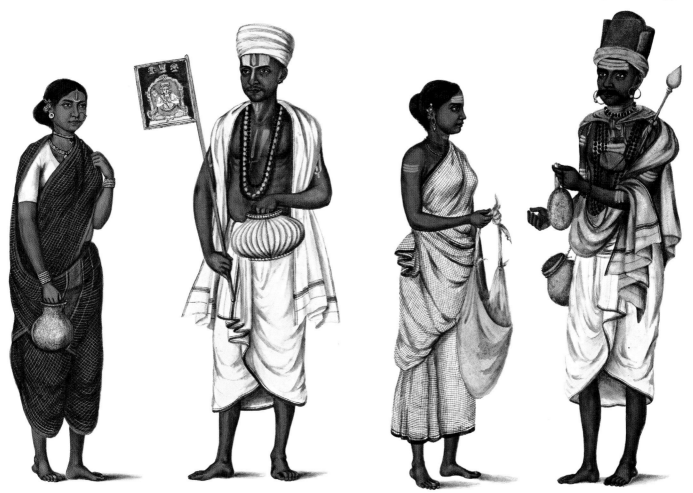

The Sattani are a class of non-Brahmin Vaishnavas. The man, wearing a turban and dressed in a white dhoti with a thin red border, shawl thrown over his shoulders, sports distinctive marks on his forehead, throat, chest and arms. Garlands of beads hang from his neck. In his right hand he carries a banner with the effigy of the philosopher Ramanuja, and in his left a ribbed begging bowl. Near him is his wife, dressed in a sari and a blouse, with a brass bowl in her right hand.

Pandarams are Shaiva mendicants. The man wears a cylindrical cap and is dressed in a white dhoti. Three horizontal marks, typical of the devotees of Shiva, are drawn on his forehead, throat, chest and arms. *Rudraksha* beads hang from his neck, and on his right wrist is a bracelet of the same beads. He carries a spear, while in his left hand he holds a gong and wooden mallet. From his right shoulder hangs a begging bowl. His wife, carrying a cloth bag, is dressed in a sari covering her breasts. On her forehead and arms are the same horizontal marks as on her husband.

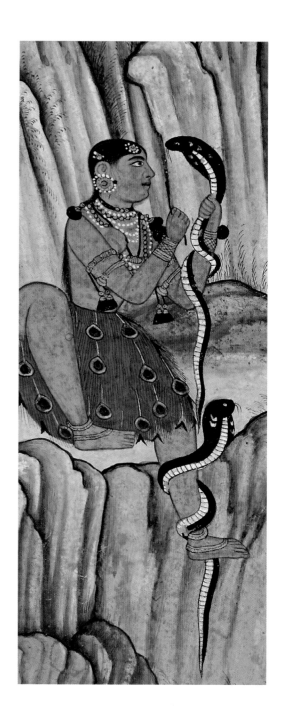

Asavari *ragini*, Manley Album, Amber (?).
Opaque watercolour on paper, *c*. 1610.

This page from a *ragamala* album illustrates *ragini* Asavari. Surrounded by rugged cliffs and dramatic rocks, a dusky beauty dressed in a peacock's feather skirt sits proudly on a rock shelf, a cobra slithering down her left leg. She holds another cobra firmly in her left hand and gazes intently at it while at her side a third snake rears its hood, as if fascinated by her. A fourth snake winds itself around the trunk of a mango tree, its head tilted towards the woman snake charmer, who seems to merge into this enchanted, mysterious and eerie landscape.

LEFT: The young woman is probably a member of the Sabara community, whose special calling is to catch and tame snakes. Her physical appearance conforms to the traditional artistic practice for rendering jungle-dwellers: dark complexion, bare chest, peacock's feather garments and ornaments of ivory or bone. Here, however, the artist has adorned her with the kind of ornament worn by courtly ladies.

ABOVE: Inspired by the rendering of mountains and rocky landscapes in contemporary Mughal painting, the artist seems to take delight in playing with shape and colour to conjure up the magical atmosphere that makes this painting unique. Particularly impressive are the two lonely *chukar* birds, each perched atop a cliff jutting into the dramatically lit sky.

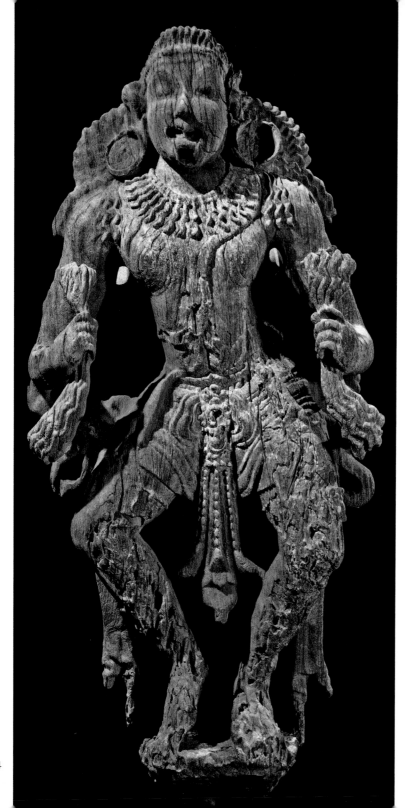

Dancer, Kerala. Wood, 15th–16th century.
This unusual image, probably an architectural strut, depicts a dancer with both legs flexed and left heel raised. Despite the amount of wear, it has not lost its impact. While dancing, he waves the streamers he holds in his hands, and his open mouth suggests that he is also singing. His dress consists of a short lower garment held by belts and a buckle with a long beaded tassel that hangs down between the legs.

He wears large earrings, and the hair fanning out over his shoulders frames an unusual face, with strong features and a powerful expression.

Musician, Kerala. Wood, 17th–18th century.
This wall panel shows a musician standing quietly beneath the shade of a tree, head slightly tilted. Dressed in a dhoti tied at the waist by an elaborate girdle, he wears a crown, earrings, numerous necklaces, shoulder ornaments, bracelets, anklets and a beaded stomach band. Firmly gripped in his left hand is a *nagasvaram*, a woodwind instrument used in ceremonies and processions. His right hand lightly touches the fronds of the tree with long pointed fingers.

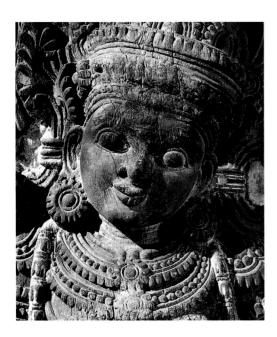

A whimsical smile plays on the lips of this wide-eyed musician, whose crown and head ornaments share the exuberance of the foliage.

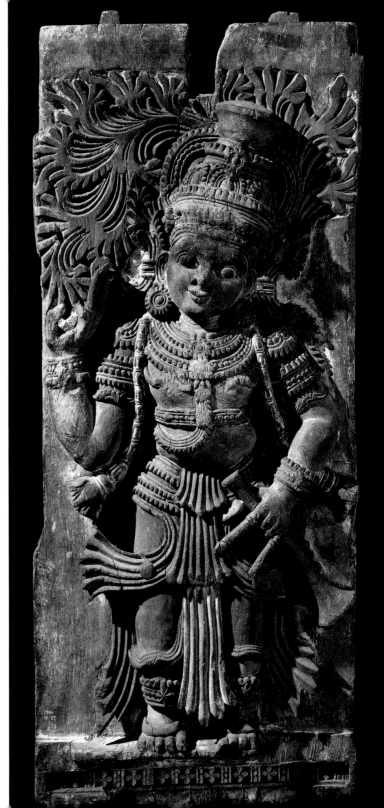

135

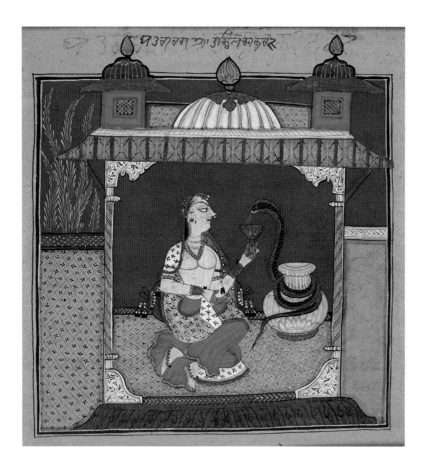

Ahiri *ragini*, Panjab Hills, Basohli, leaf from a dispersed *ragamala*.
Opaque watercolour on paper, *c*. 1720.

This intriguing painting is an illustration to *ragini* Ahiri, a musical mode which, according to the 16th-century scholar and musician Mesakarna, should sound like a snake, which explains its peculiar iconography. A lonely young woman sits in the intimacy of her own home, feeding a large snake with milk contained in an elegant goblet. The artist carefully renders every detail of the lady's mansion. Two slender pillars with elaborate capitals support its domed roof, flanked by turrets, a decorated eave and a basement adorned with a lotus-petal moulding. Behind the peripheral wall stands a tree.

RIGHT: The figure of the young woman emerges dramatically from the monochrome background. Dressed in a skirt and blouse and a transparent embroidered *odhani,* and richly bejewelled, she looks proudly at the rearing snake, coiled around a large pot, as it pauses while drinking milk from the goblet she holds in her hand.

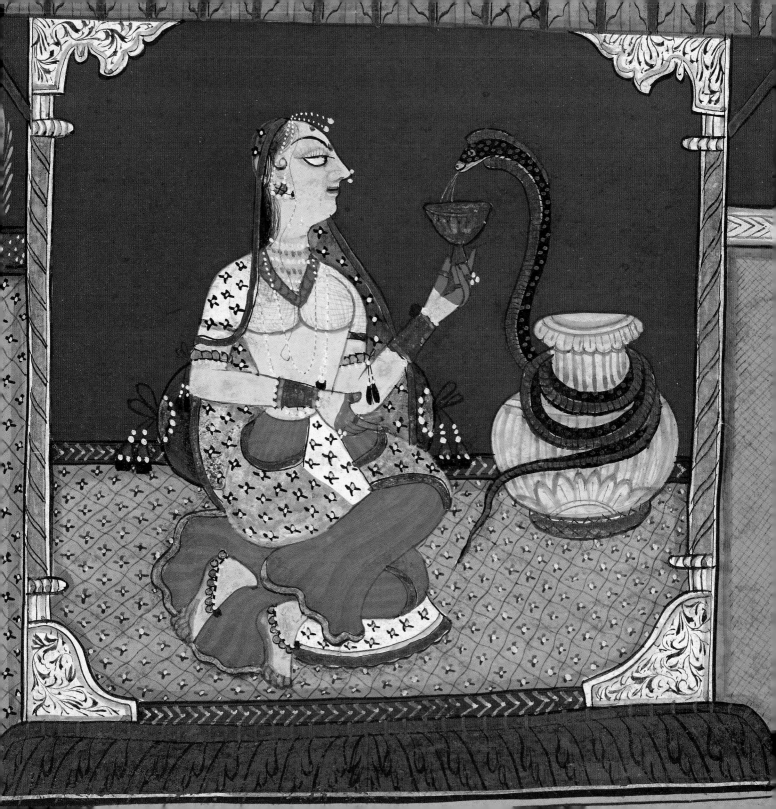

6

Further information

FURTHER READING

Indian art in general

Blurton, T.R., *Hindu Art*, London, British Museum Press, 1992 and 2001

Goswamy, B.N., *The Essence of Indian Art,* San Francisco, Asian Art Museum, 1986

Guy, J. and Swallow, D. (eds.), *Arts of India 1550–1900*, London, Victoria and Albert Museum, 1991

Huntington, S.L., *The Art of Ancient India*, New York, Weatherhill, 1985

Michell, G., *Hindu Art and Architecture*, London, Thames and Hudson, 2000

Mythology and religion

Blurton, T.R., *Bengali Myths*, London, British Museum Press, 2006

Dallapiccola, A.L., *Hindu Myths*, London, British Museum Press, 2003

Dehejia, V., *Devi, The Great Goddess: Female Divinity in South Asian Art*, Washington, DC, Arthur M. Sackler Gallery, Ahmedabad, Mapin Publishing, and Munich, Prestel Verlag, 1999

Eck, D.L., *Darshan: Seeing the Divine Image in India*, Chambersburg, Anima Books, 1985

Flood, G., *An Introduction to Hinduism*, Cambridge, Cambridge University Press, 1996

Fuller, C., *The Camphor Flame: Popular Hinduism and Society in India*, Oxford, Oxford University Press, 1992

Huyler, S., *Meeting God: Elements of Hindu Devotion*, New Haven and London, Yale University Press, 1999

Kinsley, D., *Hindu Goddesses: Visions of the Divine Feminine in the Hindu Religious Tradition*, Berkeley, Los Angeles and London, University of California Press, 1986

Knott, K., *Hinduism: A Very Short Introduction*, Oxford, Oxford University Press, 1998

Zimmer, H., *Myths and Symbols in Indian Art and Civilization*, Princeton, Princeton University Press, 1953 and 1972

Zwalf, W., *Buddhism: Art and Faith*, London, British Museum Press, 1985

Painting

Archer, M., *Company Paintings: Indian Paintings of the British Period*, London and Ahmedabad, Victoria and Albert Museum and Mapin Publishing, 1991

Barrett, D.E. and Gray, B., *Indian Painting*, Geneva, Skira, 1963

Ehnbom, D., *Indian Miniatures: The Ehrenfeld Collection*, New York, Hudson Hill Press, 1985

Falk, T.S. and Archer, M., *Indian Miniatures in the India Office Library*, London, Sotheby Parke Bernet, 1981

Losty, J.P., *The Art of the Book in India*, London, British Library, 1982

Sivaramamurti, C., *South Indian Paintings*, New Delhi, National Museum, 1968

Zebrowski, M., *Deccani Painting*, London, Sotheby Publications, 1983

Sculpture

Dehejia, V., *The Sensuous and the Sacred: Chola Bronzes from South India*, Seattle and London, American Federation of Arts, 2002

Knox, R., *Amaravati: Buddhist Sculpture from the Great Stupa*, London, British Museum Press, 1992

Michell, G., *Living Wood: Sculptural Traditions of Southern India*, Bombay, Marg, 1992

Pal, P., *Indian Sculpture in the Los Angeles County Museum*, 2 vols, Berkeley, Los Angeles County Museum of Art and University of California Press, 1986 and 1988

Pal, P., *The Peaceful Liberators: Jain Art from India*, Los Angeles, New York and London, Los Angeles County Museum of Art and Thames and Hudson, 1994

Textiles

Guy, J., *Woven Cargoes: Indian Textiles in the East*, London, Thames and Hudson, 1998

Irwin, J. and Hall, M., *Indian Painted and Printed Fabrics in the Calico Museum*, Ahmedabad, Calico Museum of Textiles, 1971

Translations and retellings of Indian classics

Dimmitt, C. and Van Buitenen, J.A.B., *Classical Hindu Mythology: A Reader in the Sanskrit Puranas*, Philadelphia, Temple University Press, 1978

O'Flaherty, W.D., *Hindu Myths: A Sourcebook Translated from the Sanskrit*, Harmondsworth, Penguin, 1975

Narayan, R.K., *Gods, Demons and Others*, London, 1965

Narayan, R.K., *The Mahabharata Retold*, Mysore, 1978

Narayan, R.K., *The Ramayana*, London, 1973

Narayana Rao, V. and Shulman, D.D., *A Poem at the Right Moment: Remembered Verses from Premodern South India*, Berkeley, Los Angeles and London, University of California Press, 1998

Ramanujan, A.K., *Hymns for the Drowning: Poems for Vishnu by Nammalvar*, Princeton, Princeton University Press, 1981

Ramanujan, A.K., *The Interior Landscape: Love Poems from a Classical Tamil Anthology*, Bloomington and London, Indiana University Press, 1967

PRINCIPAL COLLECTIONS OF INDIAN ART

United Kingdom

Ashmolean Museum, Oxford
British Museum, London
Fitzwilliam Museum, Cambridge
Victoria and Albert Museum, London

Europe

Musée Guimet, Paris, France
Museum für Indische Kunst, Dahlem, Berlin, German Federal Republic
Museum Rietberg, Zurich, Switzerland

Canada

Royal Ontario Museum, Toronto

India

Asutosh Museum of Indian Art, Calcutta
Calico Museum of Textiles, Ahmedabad
Chattrapati Shivaji Museum (formerly Prince of Wales of Western India), Mumbai
Crafts Museum, New Delhi
Government Museum, Thiruvanathapuram
Government State Museum and National Art Gallery, Chennai
Indian Museum, Calcutta
National Museum, New Delhi
Raja Dinkar Kelkar Museum, Pune
Salar Jang Museum, Hyderabad
Utensils Museum, Ahmedabad

USA

Asian Art Museum, San Francisco, CA
Brooklyn Museum, Brooklyn, NY
Cleveland Museum of Art, Cleveland, OH
Fogg Museum, Harvard University, Cambridge, MA
Freer Gallery of Art, Washington, DC
Los Angeles County Museum of Art, Los Angeles, CA
Metropolitan Museum of Art, New York, NY
Museum of Fine Art, Boston, MA
National Museum of Asian Art at the Smithsonian Institution, Washington, DC
Nelson-Atkins Museum of Art, Kansas City, MO
Philadelphia Museum of Art, Philadelphia, PA
San Diego Museum of Art, San Diego, CA
Virginia Museum of Fine Arts, Richmond, VA

Timeline

BC

c. 3000 – 1700
Harappan civilization. A sophisticated culture flourished at sites such as Harappa on the Ravi and Mohenjo Daro on the Indus. Seals, statuettes and a large number of artefacts were found.

c. 2000 – 1000
Arrival of the Aryans.

c. 1500 – 600
Composition of the *Vedas* and the *Brahmanas*.

c. 700 – 300
Composition of the *Upanishads*. Along with the *Vedas* and *Brahmanas*, these are the fundamental texts which inspired Hindu religion and ethics.

c. 527 or 526
Death of Mahavira, the founder of Jainism.

c. 486
Death of the Buddha.

4th century BC – 4th century AD
Composition of the *Ramayana* and the *Mahabharata*.

327 – 325
Alexander the Great invades India.

c. 321 – 181
Chandragupta founds the Maurya dynasty in northern India.

c. 268 – 233
Reign of Ashoka, the Maurya emperor who converted to Buddhism and whose rule extended over almost the whole of India. Beginning of rock-cut architecture.

c. 185 – 75
The Shunga dynasty rules over central India. Buddhist art flourished under their patronage, e.g. at Sanchi and Bharhut.

2nd century BC – 3rd century AD
Buddhist and Jaina influence reach their peak in India.

1st century BC – 1st century AD
Shakas, Parthians and Kushanas invade India.

1st century BC – 2nd century AD
The Satavahanas rule over parts of the Deccan, completing the great *stupa* at Amaravati in *c.* AD 200.

AD

1st – 3rd century
Reign of the Kushana dynasty in northern India. First depictions of Jaina *tirthankaras* and multi-armed Hindu deities.

4th – 5th century
The Vakatakas rule over central India and the Deccan. A major achievement are the murals in the Ajanta caves.

4th – 6th century
The Guptas reign over northern and central India. This was the so-called 'classic' period of Indian art and culture.

c. 500
First free-standing stone temples.

5th – 7th century
Spread of Vaishnavism, especially of the Krishna cult. Worship of local deities and emergence of Tantrism.

6th – 8th century
Pallava dynasty rules in southern India. Beginning of rock-cut temple architecture in the south.

6th – 10th century
Tamil devotional poetry. Beginning of the *bhakti* movement.

7th – 8th century
Decline of Buddhism in northern India. Hindu revival.

7th – 10th century
The Rashtrakutas rule over the northern Deccan. Some of the Ellora caves were cut in or hewn out of the surrounding hills. The most important of these monuments is the majestic Kailasanatha (8th century). Arab merchants settle on the coast of Sindh, Pakistan and Gujarat (early 8th century).

8th – 12th century
The Pala-Sena dynasty rules in Bihar, Bengal and large parts of eastern India. They patronized both Buddhism and Hinduism.

8th – 13th century
The Eastern Ganga dynasty rules over Orissa, responsible for the magnificent temples at Bhubaneshvar and Konarak.

9th – 11th century
The Chandella dynasty rules over central India. Under their patronage the famous temples at Khajuraho were built.

9th – 13th century
The Chola dynasty becomes the major power in southern India. They were keen patrons of the arts, and the art of bronze casting reached unsurpassed heights. Among their numerous achievements is the Rajarajeshvara temple at Thanjavur.

10th – 14th century
Hoysala dynasty settles in present-day Karnataka. They sponsor major temples at Halebid, Belur and Somnathpur.

999 – 1026
Mahmud Ghazni raids northern India.

1192
Muhammad Ghor invades India.

12th – 13th century
Buddhism disappears from India.

1211 – 1526
The Delhi Sultanate is established.

1336
Founding of the city of Vijayanagara. The supremacy of the Vijayanagara rulers quickly extended over the greater part of southern India. They were responsible not only for building a number of imposing sacred and secular buildings at Vijayanagara but for refurbishments and additions to earlier temples in various parts of their empire.

1498
Vasco da Gama lands on the Malabar coast at Kappad near Kozhikode.

1510
Goa proclaimed capital of the Portuguese Estado da India (until 1961).

1526
Babur founds the Mughal dynasty.

1526 – 1736
Rule of the Nayaks of Madurai. The city flourished and a number of important monuments were built in and around Madurai.

1556
Rule of the Mughal emperor Akbar (until 1605). Beginning of Mughal painting.

1565
Fall of the Vijayanagara empire.
1605
The Mughal emperor Jahangir comes to power (until 1627).
1613
The British establish a trading post at Surat on the Gujarat coast.
1627
The Mughal emperor Shah Jahan, the builder of the Taj Mahal, comes to power (until 1657). Expansion of Mughal power in the Deccan.
1650
The British establish a factory on the Hugly (West Bengal).
1662
With the marriage of Charles II to Catherine of Braganza, Bombay becomes a British possession.
1686
The Sultanates of the Deccan are annexed to the Mughal empire.
1690
The British East India Company establishes a trading post at Calcutta.
1757
Robert Clive defeats the Nawab of Bengal at Plassey. British power in India commences.
1772
Warren Hastings becomes the first British Governor General of India.
1828
Ram Mohan Roy founds the reformist movement *Brahmo Samaj*.
1829
Law introduced against *sati*.
1840
Introduction of photography in India.
1857
Indian uprising.
1858
The British Crown exiles the last Mughal emperor and rules India directly through a viceroy.
1875
Svami Dayananda Sarasvati founds the reformist movement *Arya Samaj*.

1877
Queen Victoria proclaimed Empress of India.
1885
The Indian National Congress is founded in Bombay.
1920
Mahatma Gandhi begins the first All-India Civil Disobedience Movement.
1931
Inauguration of New Delhi.
1947 (15 August)
Independence is granted to India and Pakistan. Caste system officially abolished.
1948 (30 January)
Assassination of Mahatma Gandhi. Pandit Nehru elected prime minister.
1950 (26 January)
The Indian Republic is declared.
1961
Indian troops reclaim Goa from Portugal.
1965
Conflict with West Pakistan. Indira Gandhi becomes prime minister.
1984
Sikhs agitate for an independent state. Indira Gandhi is assassinated by two Sikh guards.
1985
Mrs Gandhi's son, Rajiv Gandhi, is elected prime minister.
1991
Tamil extremists assassinate Rajiv Gandhi in Sriperumbudur.
1992
Destruction of the Babri mosque in Ayodhya by extremist Hindus.
1997
Kocheril Raman Narayanan, a *dalit*, is elected president of India.
2000
Formation of three new states: Uttarachal, Chattisgarh and Jarkhand.
2001 (January)
Mahakumbhamela celebrated at Allahabad.
2004 (February)
Mahamakam festival celebrated at Kumbakonam.

Glossary

Abhaya mudra, gesture of reassurance, with the palm towards the viewer

Alvar, Vaishnava poet-saints active in southern India between the 6th and 9th centuries

Anjali mudra, gesture of respect, with the two palms joined

Apsara, celestial dancer and courtesan

Ashtadikpala, the eight guardians of space

Ashvina, month corresponding to September–October

Asura, anti-god

Avatara, 'descent'; the ten incarnations of Vishnu

Barahmasa, literary composition describing the twelve months of the year

Bhuta, spirit

Bodhi, **pipal** (*ficus religiosa*), the tree beneath which the Buddha received enlightenment

Chakora, a bird, Himalayan partridge (*alectoris graeca*)

Chakra, wheel, discus, attribute of Vishnu

Damaru, hourglass-shaped drum, attribute of Shiva

Darbar, court, royal audience

Darshana, the culmination of a visit to a temple, when eye contact is made with the deity

Dharmachakra, 'Wheel of the Law', one of the most important symbols of the Buddhist faith

Dholak, a type of drum

Divali, the Hindu 'festival of lights' celebrated in October–November

Dvarapala, 'door guardian', generally two images placed at the entrance of sacred precincts

Ektara, one-stringed instrument

Gana, dwarfish, pot-bellied attendant of Shiva. Ganesha is the head of the *ganas*

Gandabherunda, a mythical double-headed eagle, carrying elephants in its talons

Gandharva, semi-divine being, musician of the gods

Garbhagriha, the temple's innermost sanctuary, where the symbol or image of the deity is enshrined

Gopi, milkmaid. The *gopis* were enamoured of Krishna

Gopura, towered gateway leading from the street into a temple enclosure, typical of south Indian architecture

Harmika, the railed portion at the summit of a *stupa*

Holi, festival which takes place in February–March marking the advent of spring; water and coloured powders are thrown on the participants

Huqqa, water-pipe

Jama, close-fitting coat with ample skirt worn by men

Jambu, rose-apple tree (*eugenia jambolana*)

Kalamkari, 'pen work', a term used for the technique of drawing and painting on cloth typical of southern India

Karttika, month corresponding to October–November

Kinnara, semi-divine being, musician of the gods, half human, half bird

Kirttimukha, decorative device in the shape of a lion-mask, frequently used in architecture

Kumbha, pot; one of the most frequent auspicious symbols in Indian art; see also **purna ghata**

Laddu, round sweetmeat offered to Ganesha

Linga, phallus, symbol of Shiva

Makara, mythical aquatic creature, symbol of fertility

Mudra, hand gesture

Naga, semi-divine being, half human, half snake

Namam, vertical lines in the shape of a U or a Y, worn on the forehead by the followers of Vishnu

Navagraha, the nine planets, generally worshipped as a group

Nayanmar, 63 Shaiva poet-saints active in south India between the 6th and 10th centuries

Odhani, women's head cover

Pachisi, board game

Paduka, toe-knob sandals generally worn by ascetics or deities such as Virabhadra or Bhairava

Pan, leaves of the betel plant wrapped around chopped ingredients, e.g. spices, areca nut and lime, and chewed

Patka, courtly sash

Peshwaz, skirt of a light material worn over the pijama

Phalguna, month corresponding to February-March

Pijama, trousers

Puja, worship

Purna ghata, 'vase of plenty', one of the auspicious symbols in Indian art

Raga, one of six 'male' melodies, each of which has five or six 'wives'; see **ragini**

Ragamala, 'garland of melodies', a series of paintings evoking the moods of music through images and poetry

Ragini, 'female' melody, 'wife' of a **raga**

Raksasa, demon, malevolent spirit

Ratha (Tamil: *ter*), chariot

Rathotsava, chariot festival

Rishi, mythical seer

Rudraksha, the dried berries of the *elaeocarpus sphericus*, from which are made necklaces and chaplets worn by devotees of Shiva

Rumal, towel or handkerchief

Sadhu, renouncer, a mendicant who has abandoned conventional life

Shalabhanjika, tree nymph

Shankha, conch, attribute of Vishnu

Shravana, month corresponding to July–August

Stupa, the most important Buddhist domed monument commemorative of the Buddha

Svastika, auspicious mark connected with solar symbolism

Tabla, set of two small kettle drums, used mainly in north Indian music

Tamboura, string instrument

Tilaka, mark drawn on the forehead; varies according to religious group and community

Tirthankara, 'ford maker', a Jain prophet

Tripundra, three horizontal marks worn on the forehead by Shiva's devotees

Triratna, 'Three Jewels' of Buddhism: the Buddha, the Law and the Community

Trishula, trident, attribute of Shiva

Vahana, vehicle; the conveyance of a deity

Vaishakha, month corresponding to April–May

Varada mudra, grant-giving gesture, palm out and fingers pointing downwards

Vibhuti, sacred ash generally worn on the forehead by the followers of Shiva

Vina, string instrument

Yaksha, **yakshi**, nature spirit

Yali, mythical animal, part lion, part elephant

Yuga, 'age of the world'; in each creative cycle there are four *yugas* of decreasing length and increasing physical and moral deterioration

Zenana, women's apartment

British Museum registration numbers

Chapter 2
1974 02 25 1
1924 04 01 2
1965 10 17 3, 4
1965 12 13 1
1971 09 10 07
2005 06 04 1
1956 05 12 07
1872 07 01 67
1853 01 08 8
K 3
1987 03 14 1
2001 11 26 1
1955 10 18 1
1872 07 01 70
1974 06 17 014 (7)
1984 04 03 1
1967 10 17 1
1842 12 10 1
1976 06 21 1
1955 10 08 95 (xlii)
1965 10 17 2
1919 11 04 40
1955 10 18 2
1872 07 01 83
1894 02 16 10
1951 07 20 02
1940 07 16 29
1995 10 03 01

Chapter 3
2003 10 13 04
1993 07 24 02
1955 10 08 096 (viii)
1995 10 06 1
1991 03 27 01
1972 04 10 01
1957 07 13 02
1996 06 15 01 (xviii)
1996 06 15 01 (xvi)
2003 10 13 04

Chapter 4
1962 12 31 013 (1)
1880 03 04
1962 12 31 013 (69)
2005 01 12 05
1974 06 17 014 (5)
1793 05 11 1
1990 10 29 07
1997 02 05 01
1973 09 17 03
1880 07 09 108
1956 07 14 035
1880 07 09 39
1882 10 10 26
2002 10 19 01

Chapter 5
1999 12 02 05 (3)
1937 06 10 02
1920 09 17 013 (16)
1937 04 10 01
1948 10 09 099
1999 12 02 05 (5)
1948 10 09 0130
1999 12 02 05 (7)
1948 10 09 0148
1997 01 27 02
1953 04 11 010
1913 04 15 04
1955 10 08 095 (xiii and xiv)
1948 10 09 0156
2005 05 03 01
1973 09 17 08
1966 12 16 3
1961 10 22 1
1948 10 09 0108

Index

abhaya mudra 15
Amaravati 98, 100
animals 14, 37, 39, 74, 98, 105, 109, 124, 127
 fabulous 45, 75, 79, 103, 121
anjali mudra 22, 54, 63, 66, 99
architecture 58, 110, 127
ascetics 37, 45, 60
auspicious motifs 9, 46, 76, 84, 87, 102, 103
banyan tree 81, 96, 117
Bhagavadgita 59
Bhagavata Purana 68, 70
Bhairava 38–9
Bhuta (spirit cult) 55
birds 20, 22, 23, 33, 49, 74, 75, 97, 100, 113, 133
book 17, 45
Brahma 10, 23, 31
Brahmanism 67
brass 24, 46
Bridge Collection 7
British Museum 6–7, 90
bronze 14, 26, 28, 30, 36, 38, 54, 55, 94, 102
Brooke Sewell, Percy 7
Buddha 9, 98, 100
Buddhism 42, 55
Buddhist art 12, 21, 40
Buddhist sites 7
chakra, see discus
chakravartin 104
chariot (*ter*) 86–90
Chola period 14, 36
clay 8, 50, 128
cloth,
cloth, painted 9, 60, 64, 66, 103
 pigments on 17, 18, 72, 74, 82
cobra 22, 29, 34, 38, 46, 54, 100, 132
 see also naga, snake
conch (*shankha*) 15, 17, 18, 20, 34, 66, 82, 130
creation, symbols of 21, 28
creation myths 59
dancing, images of 11, 24, 28, 36, 50, 134
death 9, 59, 60
discus (*chakra*) 15, 17, 18, 20, 52, 66, 82
Divali 79, 110
drawings 6
 pen and ink 86, 92
 see also painting, watercolour
drum 28, 33, 38, 42
Durga 46, 50, 79
East India Company 6
Ekadasi 86

elephant 12, 13, 26, 33, 70, 74, 80
epic poetry 10, 58
eyes 20, 36, 39, 57, 63, 76, 83, 135
 bulging 38, 46, 49, 67
female images 9, 33, 40, 45, 118
 dark-complexioned 34, 51, 133
 light-complexioned 34fire 54, 59, 60, 62, 79, 127
fish 43, 82
flames 24, 28, 31, 36, 48, 54, 59, 62, 127
floral motifs 18, 34, 36, 98, 107, 118, 127
flowers 12, 20, 26, 40, 63, 66, 69, 84, 86, 97, 99, 106, 108, 113, 117
foliage 26, 41, 42, 67, 112, 135
Franks, Sir Augustus Wollaston 7
Gaja Lakshmi 12, 26
gandabherunda (mythical bird) 74
Gandhi, Mrs Indira 56–7
Ganesha 83, 92, 129
Ganga 29, 45
granite 31, 48
Hindu art 6, 12, 21, 28, 40, 104
 mythology 22, 75, 90, 98, 100, 127
Hindu Pantheon (Edward Moor) 54
Hinduism 8, 42, 55, 78
Holi 79
human body 9, 19, 22, 46, 102, 105
 couples 105, 112, 117, 120
India Museum 7
ivory 8, 63, 133
Jainism 8, 21, 40, 42
jewellery 12, 15, 22, 24, 26, 29, 30, 33, 36, 40, 46, 52, 54, 84, 105, 107
 see also ornaments
Kalamkari (painted cloths) 18, 60, 64, 66
Kali 11, 48, 50–1, 129
kirttimukha ('face of glory') 31, 46, 67
Krishna 6, 24, 26, 59, 63, 68, 70, 99, 105, 112, 117
lion 26, 33, 46, 52, 54, 83, 102
lotus 12, 17, 18, 20–1, 24, 26, 28, 33, 37, 63, 66, 97, 100, 113, 117, 136
Mahabharata 58, 59, 64, 70
Mahisha 46, 79
marble 98, 100
moon, crescent 29, 52, 54
Moor, Edward 54
Mughal art 105, 107, 118, 124, 133
naga 24, 98, 100
 see also cobra, snake
Nainsukh 104, 110, 114, 118
Nandi 30, 54, 84, 96
Narasimha (man-lion) 64, 67, 74, 75
nature, celebration of 9, 21, 41

ornaments 84, 97, 102, 130, 133, 134
 see also jewellery
painting 6, 9, 17, 62, 64, 68, 80, 96, 99, 103, 104, 105, 106, 107, 108, 110, 112, 118, 122, 128, 133, 136
 see also drawings, *ragamalas*, watercolour
palanquin 36, 92
Panjurli (boar spirit) 55
patronage 8, 114
peacock 34, 72, 74, 113, 117, 130, 132
portraits 104, 106, 107, 114
printing 64
prints 6
Puranas (old stories) 58, 68, 70
ragamalas 105, 132, 136
Ramayana 58, 60, 62
rebirth 9, 60, 103
sandstone 11, 40, 42, 45, 49
schist 8, 22, 33, 52
scroll 43, 56, 62, 72, 74, 127
sculpture 6, 8, 36, 52, 120
shalabhanjika (tree spirit) 40, 41, 42
shankha, see conch
Shiva 6, 10, 28, 29, 30, 31, 33, 34, 36, 37, 38, 45, 50, 54, 92, 93, 96, 97, 113, 117, 129
Shri Ranganatha 67, 80
silver 46
Sloane, Sir Hans 7
snake 17, 18, 22, 29, 34, 39, 49, 66, 74, 100, 132, 133, 136
 see also cobra, *naga*
Srirangam 64, 66, 78, 80, 86, 88
Stuart, Major-General Charles 'Hindoo' 7
stupa 40, 98, 100
sun 22, 52, 54, 62
temple 8, 64, 67, 78–9, 80, 86, 88
textiles 78
 see also cloth
third eye 33
tiger 55, 72, 74, 104, 129
tree 9, 20, 24, 26, 34, 40, 42, 68, 74, 76, 81, 90, 92, 94, 98, 103, 104, 110, 113, 117, 122, 130, 132, 135, 136
varada mudra 34, 37
Vedic tradition 10, 58
Vishnu 10, 14, 15, 17, 18, 19, 20, 21, 22, 31, 52, 63, 64, 66, 67, 82, 86
watercolour 12, 20, 34, 43, 56, 62, 68, 70, 76, 80, 84, 88, 96, 99, 105, 106, 107, 108, 110, 112, 114, 117, 118, 122, 124, 127, 128, 130, 132, 136
 see also drawings, painting
wood 8, 83, 90, 120, 134, 135
yakshas (nature spirits) 42